Studios of Their Own

Studios of Their Own

Where Great Artists Work

Alex Johnson
Illustrations by James Oses

Contents

6 *Introduction*

10 *Francis Bacon*
14 *Jean-Michel Basquiat*
18 *Edward Bawden*
22 *Vanessa Bell*
24 *Rosa Bonheur*
28 *Louise Bourgeois*
32 *Constantin Brâncusi*
34 *Alexander Calder*
38 *Julia Margaret Cameron*
40 *Caravaggio*
44 *Paul Cézanne*
48 *Marc Chagall*
50 *Winston Churchill*
54 *Leonardo da Vinci*
56 *Giorgio de Chirico*
58 *Eugène Delacroix*
62 *Albrecht Dürer*

66 *Tracey Emin*
70 *Artemisia Gentileschi*
74 *Barbara Hepworth*
80 *David Hockney*
84 *Katsushika Hokusai*
88 *Tove Jansson*
92 *Frida Kahlo*
96 *Angelica Kauffman*
100 *Laura Knight*
104 *Yayoi Kusama*
108 *René Magritte*
112 *Michelangelo*
116 *Joan Miró*
122 *Amedeo Modigliani*
126 *Piet Mondrian*
128 *Claude Monet*
132 *Giorgio Morandi*

134	Sidney Nolan		186	Visitor information
138	Georgia O'Keeffe		188	Index
142	Pablo Picasso		191	Picture credits
144	Jackson Pollock and Lee Krasner			
148	Paula Rego			
150	Rembrandt van Rijn			
154	Faith Ringgold			
158	Auguste Rodin			
160	Jenny Saville			
162	Yinka Shonibare			
164	Posy Simmonds			
168	Joaquín Sorolla			
170	Suzanne Valadon			
172	Vincent van Gogh			
176	Kara Walker			
180	Andy Warhol			
184	Rachel Whiteread			

Introduction

'Of my sister at work, we saw very little. She very wisely made it a fixed rule that, during working hours, no one should come into the studio save on matters of urgency.'

John Greenaway, quoted in *Kate Greenaway* by Marion Harry Spielmann and George Somes Layard (1905)

The nineteenth-century artist and illustrator Kate Greenaway loved her studio at 39 Frognal, Hampstead, London, designed for her by eminent Victorian architect Norman Shaw with a specially angled window in order to catch the north-eastern light. It was her personal, private place, the kind of space that novelist Virginia Woolf prescribed as an essential tool of the creative trade (especially for women), 'a room of one's own'.

In our previous book, *Rooms of Their Own* (2022), James and I explored the workspaces of writers. In this new collaboration the focus is on painters, sculptors, photographers, quilters and installation artists around the world and the places where they created their masterpieces, not all with four walls and a lock on the door.

The concept of a studio has changed dramatically over time, as the entries in the following pages will reveal. Even the word itself is relatively new in terms of designating the space where an artist works, not in use until the late 1600s in Italy and in Britain from about 200 years later.

It's also a story about changing technology. In the second half of the nineteenth century, advances in how paints could be stored in metal tubes, not to mention more manageable easels, enabled artists to get out of the studio and into the outdoors. Transportation hacks also allowed Georgia O'Keeffe to use her car as a mobile studio and Roger Fenton to travel the Crimean battlefields in his photographic van.

But what has not changed is the importance that artists attach to their workspace, whatever its physical properties (or lack of them). According to the writer and photographer Maxime Du Camp, Eugène Delacroix 'loved only his studio

and it was there he preferred to live.' Paul Klee treasured his two studios in Dessau and Düsseldorf, oscillating between them and enjoying returning to the works in progress in each, or what his son Felix described as his 'half-finished children'.

Sculptor Henry Moore went a step further and had a whole network of shed studios in the grounds of his home at Perry Green in Hertfordshire — a former stable house, the old village shop (for making maquettes and later printmaking), a carving studio, a 15m- (50ft-) tall metal structure with walls of corrugated plastic and sheets of polythene for larger works, and a rotating summer house for drawing.

The studio has also been a particularly important place for female artists, effectively barred from the male-run art world and its academies. Having a 'room of one's own' allowed them a precious space in which to prove their expertise.

Many studios are gone now, demolished or entirely repurposed. And some studios never even existed. Tony Hancock's wannabe artist in the satirical 1961 film *The Rebel* revels in an atmospheric studio in Paris where he keeps a pet cow and flings paint onto an enormous canvas then saunters over and cycles on it, with apologies to Jackson Pollock. It would also have been intriguing to enjoy the studio envisaged by Duncan Grant for Vanessa Bell's home in Gordon Square, London; she wrote to her husband Clive in December 1912 that her lover's plan was 'to turn my studio into a tropical forest with great red figures on the walls — a blue ceiling with birds of paradise floating from it (my idea), and curtains each one different.' Grant also wanted to build a bath into the floor …

But you can still visit plenty of them. Painter Walter Sickert said of plans to museumize Sir Frederick Leighton's house, 'Do not let us consecrate in perpetuity the hotel, now that the

brilliant guest has gone', but artist museums make an exceptional effort to maintain the atmosphere of a working studio where the artist in question has merely stepped out for a moment. I vividly remember the first time I visited Joaquín Sorolla's house in Madrid and being stunned not only by his marvellous studio, but also the beautiful gardens that he designed and found inspiring. Charleston in Sussex where Vanessa Bell painted is another favourite spot, a remarkable home where art is an integral part of the rooms throughout.

 They are certainly very popular and their growth has spawned several useful websites gathering them together. The Artist's Studio Museum Network details over 150 single-artist museums in Europe (www.artiststudiomuseum.org) under the mission statement 'Discover the spaces that inspired the art'. The Historic Artists' Homes and Studios program (artistshomes.org) brings together 55 museums that were once the homes and working studios of American artists ('Come, witness creativity').

 What comes through strongly is that while hard work is at the centre of these artists' success, so is allowing themselves time for enjoying life away from work, whether that's partying (Andy Warhol), gardening (Edward Bawden), exercising (Joan Miró) or simply getting away from it all for a bit. While there is, of course, room for spontaneity (an approach endorsed strongly by David Hockney), most of the artists featured in this book followed a fairly regular routine. Here is Kate Greenaway again and her days as remembered by her brother John:

Her great working time was the morning, so she was always an early riser and finished breakfast by 8 o'clock. Her most important work was done between then and luncheon time (1 o'clock). Practically she never went out in the morning. After luncheon she usually worked for an hour or two, unless she was going out anywhere for the afternoon; and then went for a walk on the Heath, and came back to tea. The evenings up to 8 o'clock, when we had a meal that was a sort of compromise between dinner and supper, were spent in letter-writing, making dresses for models, occasionally working out schemes and rough sketches for projected books and such-like things; but all finished work was done in the morning or afternoon. In the summer too, a good deal of this time was spent in the garden seeing to her flowers. After supper she generally lay on a sofa and read until she went to bed at about 10 o'clock.

Another common thread, an understandably very practical one, is the importance of light and decoration in their studios. Popular Victorian painter Sir Lawrence Alma-Tadema told *Strand Magazine* in 1899 that:

> I have always found that the light and colour in a studio had a great influence upon me in my work. I first painted in a studio with panels of black decoration. Then in my studio in Brussels I was surrounded by bright red, and in London I worked under the influence of a light green tint. During the winter I spent in Rome I tried the effect of a white studio. Now, as you see, the prevailing hue is silvery white, and that, I think, best agrees with my present temperament, artistically speaking.

These are also places where artists could work alone and undisturbed. Most admitted very few visitors into the nerve centre of operations, often excluding their own families. Even when painters who are partners work together, the examples in this book show that they rarely intruded into each other's studio space; invitation required, not open house.

Rooms of Their Own focused on the spaces that tell stories. *Studios of Their Own* is all about the ones that paint pictures.

Francis Bacon
At home in the chaos

7 Reece Mews, South Kensington, London, England

Francis Bacon's studio:
'Like walking into the
artist's head'.

Francis Bacon's (1909–92) studio at 7 Reece Mews has had two remarkable lives, first at its original location in South Kensington, London, and then, later, in Dublin.

Bacon was born in Dublin before moving to Paris (where he had a studio at 14 rue de Birague in the Marais district), then London, where he set up a studio and illegal gambling den in collaboration with his former nanny, Jessie Lightfoot, at 7 Cromwell Place, the former atelier of nineteenth-century painter John Everett Millais. He then worked in a small studio in the former Victorian coach house at Reece Mews from 1961 until he died.

The living quarters were on the first floor up a very steep and narrow staircase — they were very simple, with a bath in the kitchen, a bedroom, and then the 4 x 6m (13 x 20ft) studio (a former hayloft) across the landing.

The studio was not just a bit untidy; it was monumentally chaotic. Bacon worked in the centre of the room, a skylight offering some natural light, with the walls and floor covered in a mess of newspaper and magazine cuttings, photographs (including work by Cecil Beaton and Henri Cartier-Bresson), piles of books, reproductions of paintings, canvases, painting tools, and empty boxes of wine and champagne, all of which were spattered with paint drips. Here, too, were drawings (his own as well as reproductions by other artists such as Michelangelo, see page 112), letters, vinyl records and furniture —including a round mirror that had the effect of making the studio look slightly larger. Some of the material had been there for decades.

'I feel at home here in this chaos,' he said, 'because the chaos suggests images to me.' When the colourful clutter became too overpowering and prevented him from moving properly around his work, friends would help with temporary clear-outs — he never made any attempt to change this very productive working

practice. Very few people were granted access, even when he wasn't at work, and smoking there was never allowed since Bacon feared it was a fire hazard. Hugh Lane Gallery director Barbara Dawson described the studio as 'like walking into the artist's head'. Bacon himself once called it a 'dump'.

The studio remained untouched, just as he left it, until 1998, when his heir and executor donated Bacon's London studio — lock, stock and barrel — to the Hugh Lane Gallery in Dublin. After cataloguing each of the more than 7,000 objects inside it (including 1,500 photos and 1,300 pages ripped out of books), the studio opened to the public in 2001, an online database offering a full listing.

The studio was not just a bit untidy; it was monumentally chaotic. Bacon worked in the centre of the room, a skylight offering some natural light, with the walls and floor covered …

In addition to the floor, walls, doors (which he used as palettes) and ceiling, the conservators were also careful to gather the dust from around the studio as well as items such as fragments of his corduroy trousers, which Bacon added to his paintings, not to mention various deliberately slashed works and a portrait of artist Lucian Freud stuck to the front of another canvas. It was an almost archaeological operation, removing layers carefully so that the reconstruction in a purpose-built, climate-controlled space in the museum could be as exact as possible. It has become a piece of art in itself.

Jean-Michel Basquiat
Studio as shrine

57 Great Jones Street, New York, USA

Basquiat's space has become a popular shrine.

What happens to studios once the artist has gone? Some are knocked down, some are turned into museums, but in Jean-Michel Basquiat's (1960–88) case it became a shrine, a restaurant, a bone of contention among local residents and, most recently, the headquarters of a Hollywood film star's latest venture.

Basquiat's early work under the tag 'SAMO' didn't require a studio at all since it was street art in Lower Manhattan and the D Train to Brooklyn, a mixture of epigram-based graffiti and work on found objects such as doors and pieces of foam.

He took his first studio in 1981, offered to him by gallery owner Annina Nosei, a basement at her Prince Street location. Here, he worked a nine-to-five day with the television or music constantly on in the background. Nosei became his dealer, but Basquiat complained that she brought in potential buyers unannounced and encouraged him to work faster, even selling his work before it was really finished. The following year he moved to a loft space at 101 Crosby Street in SoHo, and later in the year to a studio at art dealer Larry Gagosian's home in Venice, California. But it was the 57 Great Jones Street studio in NoHo, his last, that Basquiat moved into in August 1983, that is most closely associated with his greatest work.

In the early twentieth century this space was owned by gangsters, then later was a metal works, followed by a kitchen-supplies operation. By the 1980s it had been bought by Andy Warhol who rented the second floor to Basquiat as well as collaborating with him. He welcomed visitors but would carry on working while they talked or listened to music.

The studio (and indeed the kitchen and sitting room of the home he grew up in) was recreated in an exhibition of his work at the Grand LA in New York. It included the bicycle he used for getting around on in addition to a paint-spattered

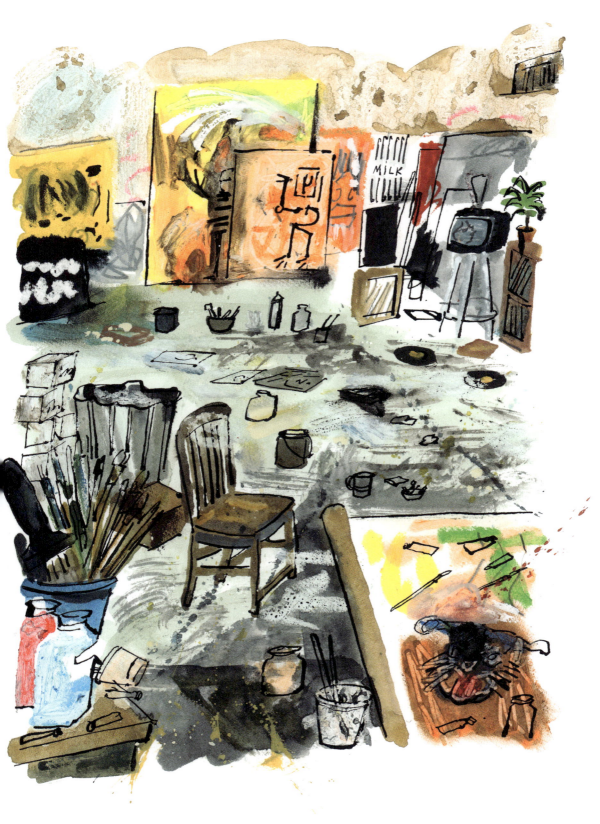

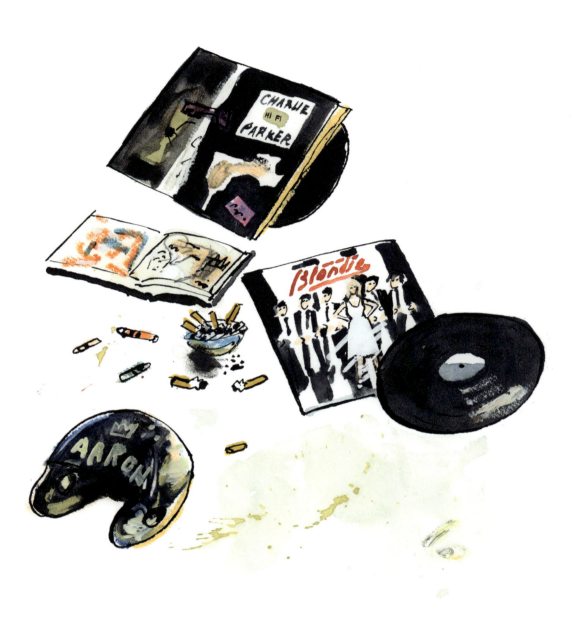

floor, sketchbooks and a smattering of cigarette butts, all with a soundtrack of the music he enjoyed as he worked, from Charlie Parker and John Coltrane to Blondie — his collection of vinyl totalled around 3,000 records.

After his death, the studio's façade became a de facto shrine. A plaque on the wall outside put up by the Greenwich Village Society for Historic Preservation in July 2016 reads: 'Renowned artist Jean-Michel Basquiat lived and worked here, a former stable owned by sometime friend and mentor Andy Warhol. Basquiat's paintings and other work challenged established notions of high and low art, race and class, while forging a visionary language that defied characterization.'

Fans also decorated the exterior with spray-painted homages to his work including versions of his crown motif and a Basquiat-like Statue of Liberty silhouette.

Fans also decorated the exterior with spray-painted homages to his work including versions of his crown motif and a Basquiat-like Statue of Liberty silhouette. This did not sit well with some locals who complained that it should have been removed (or indeed never allowed in the first place). It then became an exclusive Japanese restaurant called Bohemian and in 2022 came onto the market to rent for a mere $60,000 a month.

In 2023 it was also mysteriously 'whitewashed' and painted over in pink, another street artist later admitting responsibility, but there was plenty of interest in the property and, in the end, it was snapped up by actress Angelina Jolie. Her plan is to use it as the headquarters for her Atelier Jolie tailoring business ('We will do our best to respect and honor its artist legacy with community and creativity,' says the website).

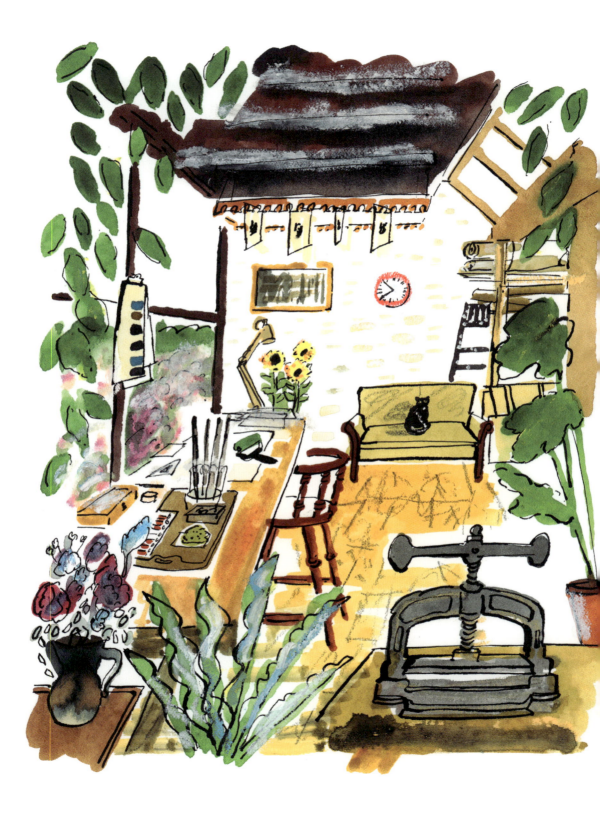

Edward Bawden
The inspiration of a garden

Brick House, Great Bardfield, Essex, England

Emma Nelson on the sofa in Edward Bawden's studio.

A prolific artist of many talents — painter, wallpaper designer, book illustrator, linocut and printmaker, muralist — Edward Bawden (1903–89) was totally dedicated to his craft, producing colourful work for major companies such as Fortnum & Mason, but also with a love of exploring the commonplace elements of English life. Talking about his resolute work routine in a 1983 television documentary, he admitted: 'I've got into the habit and I can't easily get out of it.'

For much of his working life, Bawden lived at the eighteenth-century Brick House in Great Bardfield, Essex, bought for him as a wedding present by his father in 1932. Here, he was part of the Great Bardfield Artists movement, as was his great friend Eric Ravilious. Ravilious also lived with him briefly and painted an elegant depiction of Bawden at work in his studio in 1930 at Redcliffe Road, Chelsea. Complete with dark floorboards, walls and curtains in matching yellows, and canvases leaning against a cast-iron fireplace topped with an ornate rococo mirror, Bawden is shown at work on a painting of Clacton Pier; in the corner are rolled-up studies for a mural the two were working on at the city's Morley College canteen (later destroyed in the Blitz, though he completed another after the Second World War depicting *The Canterbury Tales* in the same location, which can still be seen).

While Ravilious himself worked in intriguing surroundings around this time — a former fever wagon from the Boer War repurposed to serve as a workspace for him and his wife Tirzah — Bawden's studio was in the high-ceilinged attic of Brick House. Before embarking on his day's work, indeed often before breakfast, he would spend at least an hour attending to the daily jobs in the garden. He particularly liked large-leafed architectural plants, like gunnera, and had a special soft spot for sunflowers. He often used the garden as direct inspiration;

his Autumn linocut from 1950 features his greenhouse. Then he would work hard for the rest of the day, largely in silence, though with a two-hour break after lunch.

Brick House (the only building in the village to be bombed during the Second World War) also played an important part in the development of one of the most popular recent trends in artists' studios. In the second half of the 1950s, Bawden and his fellow Bardfield artists arranged several 'open house' exhibitions. Members of the public were encouraged to come along to these groundbreaking events and view the work of the artists in their own homes and studios, an early version of the popular open-studio events held regularly today. Thousands of people took up the opportunity to see both the artists' work and where it was produced.

Bawden's final studio was on the top floor at the back of the home he moved to in Saffron Walden just after his wife Charlotte died — he sold many of his books to give himself more working space in the 6 x 3.5m (20 x 12ft) room, but later regretted this and spent years trying to buy them back again. Wide windows offered him plenty of natural light and allowed him views of his garden, although he filled the studio with plants too. A small sofa provided comfortable respite from his long work bench, which he kept extremely tidy. He also had a large drying rack, worked on a pulley system, with a printing press in a separate room. The walls were hung with examples of his own work and a trap door was built into the floor to allow him to bring mural panels in and out.

As he became less mobile, his watercolours increasingly featured the rooms in the house, including the studio. So did his black cat, a stray, Emma Nelson (so-called because she was initially thought to be male) who can be seen in several of his later works nestled into his working space.

Wide windows offered him plenty of natural light and allowed him views of his garden, although he filled the studio with plants too.

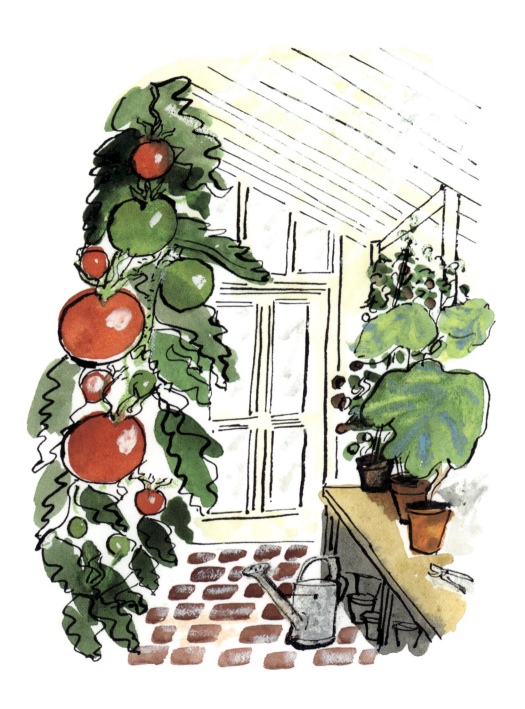

Vanessa Bell
An attic of one's own

Charleston Farmhouse, Firle, East Sussex, England

Charleston Farmhouse in Firle, East Sussex, was the country retreat of the Bloomsbury Group from 1916 when painters Vanessa Bell and Duncan Grant first moved there with Grant's lover David Garnett (Bell's husband Clive visited regularly too). Initially the two painters used an old army hut on the property as a workspace, nicknamed Les Misérables for its unwelcoming interior, but in 1925 erected a purpose-built studio onto the house replacing a chicken run. Bell was delighted with it. She wrote to her friend, the critic Roger Fry who had helped with its design, that 'It is the perfect place to work in'. The walls were painted dark as a background for their bright paintings. It was decorated, as elsewhere in the house, with painted tiles and furniture, including a decorated screen and mantlepiece painted by Grant in oil on plywood.

They painted here until just before the Second World War. Vanessa's son Quentin described them working happily together 'like two sturdy animals side by side in a manger'. Then, in April 1939, Vanessa turned the attic into a studio solely for herself, leaving Duncan downstairs. Although Vanessa was sociable, the attic was much quieter and she could work there uninterrupted by visitors and household management. A window was fitted to improve light and gave a view over the countryside. She worked up here for the last two decades of her life, surrounded by her canvases, sewing machine, a large mirror for self-portraits, photograph albums and her sister Virginia Woolf's books.

The studio appears in several of her paintings including *Self Portrait* and *The Artist in her Studio* (both 1952), which also includes her armchair for which she designed the fabric. Her daughter Angelica said her mother was 'in heaven' working in this studio, and her granddaughter Henrietta Garnett said being up there was 'like looking at life from the height of a campanile tower'.

The attic studio that offered Bell peace and quiet.

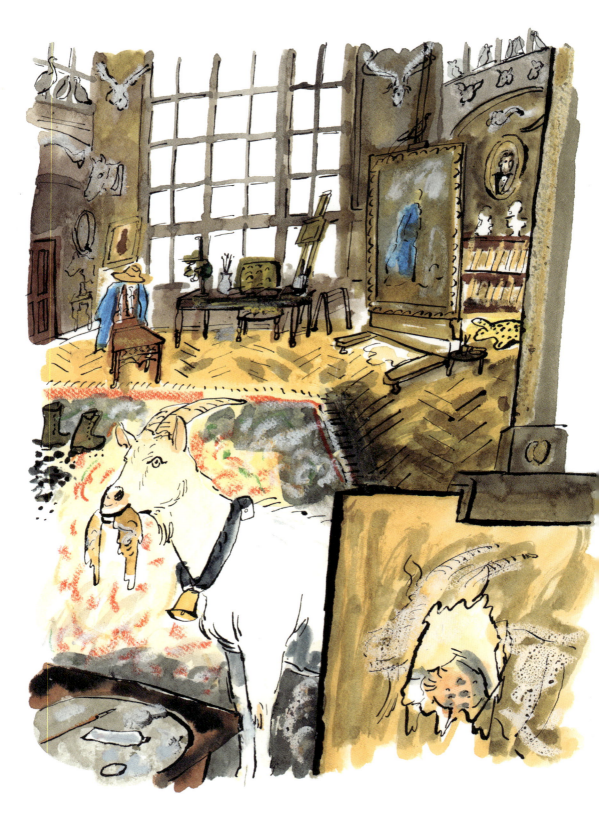

Rosa Bonheur
A studio full of animals

Various studios, Paris, France

'They give me ideas,' said Bonheur of her animal collection.

Rosa Bonheur's realist paintings of animals propelled her to becoming arguably the most famous nineteenth-century female painter. And from her earliest working days, she also welcomed them into her studios.

Her first studio was shared with her painter father Raymond and three siblings. She described this studio in Paris in her autobiography as rarely swept and chaotic, not helped by the sheep and goats that she kept in the apartment. She took these with her when she moved to her own studio on Rue de l'Ouest as an 1852 engraving in contemporary magazine *L'Illustration* indicates — it shows Bonheur (1822–99) calmly at work surrounded by horses, sheep and dogs, all comfortably in their own stabling areas.

The animals travelled with her again when she moved to a large studio in the Rue d'Assas, complete with internal courtyard where she kept her menagerie of birds, goats and an otter. The workplace was described by American writer Elizabeth Fries Ellet in her 1859 book *Woman Artists in All Ages and Countries*:

> This beautiful studio, one of the largest and most finely proportioned in Paris, with its greenish-gray walls, and plain green curtains to lofty windows that never let in daylight has all its wood-work of dark oak, as are the book-case, tables, chairs, and other articles of furniture distributed about the room. The walls are covered with paintings, sketches, casts, old armor, fishing-nets, rude baskets and pouches, poles, gnarled and twisted vine-branches, picturesque hats, cloaks, and sandals, collected by the artist in her wanderings among the peasants of various regions; nondescript draperies, bones and skins of animals, antlers and horns.
>
> The fine old book-case contains as many casts, skeletons, and curiosities as books, and is surrounded with as many

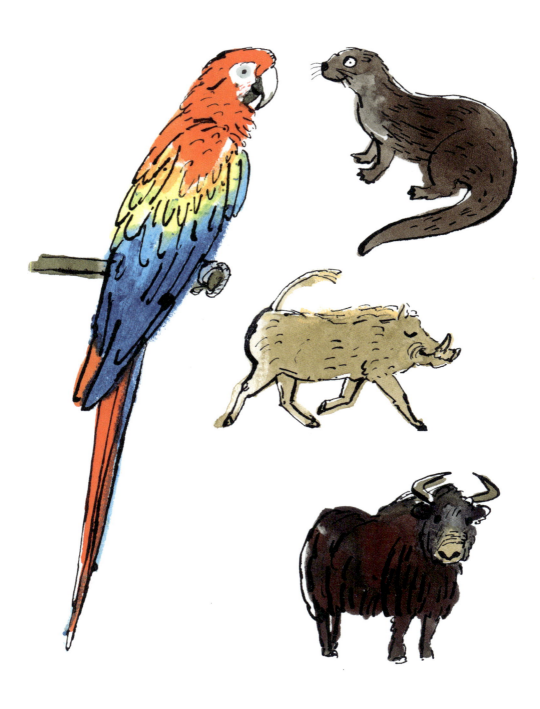

busts, groups in plaster, shields, and other artistic booty, as its top can accommodate; and the great Gothic-looking stove at the upper end of the room is covered in the same way with little casts and bronzes. Paintings of all sizes, and in every stage of progress, are seen on easels at the lower end of the room, the artist always working at several at a time. Stands of portfolios and stacks of canvas line the sides of the studio; birds are chirping in cages of various dimensions, and a magnificent parrot eyes you suspiciously from the top of a lofty perch. Scattered over a floor as bright as waxing can make it, are skins of tigers, oxen, leopards, and foxes. 'They give me ideas,' she says of these favorite appurtenances; 'whereas the most costly and luxurious carpet is suggestive of nothing.'

Her final studio was 64km (40 miles) south of Paris in Fontainebleau forest at the Château de By, which she bought with her partner Nathalie Micas. 'I paid the first installment on August 9, 1859,' she wrote in her autobiography, 'and began building a studio over the toolshed and laundry.' In this neo-Gothic addition she kept her studies in folders categorized by animal, while around the walls were the stuffed heads of her favourite deceased animals.

In addition to the usual menagerie of farm animals, she enlarged her collection to include more exotic ones such as lions (the skin of Fathma her lioness is near her easel), wild boar and a yak. These were kept outside in their own quarters, roaming free in the grounds where Bonheur sketched them. She enjoyed working outdoors and won dispensation to wear trousers and men's clothes in general, a practice then legally forbidden to women, so as to blend in with the all-male crowd while sketching horses.

Bonheur was awarded the Légion d'honneur by Empress Eugénie in 1865. Her studio has been kept as she left it on her death, with her clothes, boots, paintings and sculptures, palettes and even cigarette butts on show.

Louise Bourgeois
The delights of decrepit splendour

347 West 20th Street, New York, USA

Bourgeois: blurring the line between home and studio.

While there is often some element of general work creep from studios into the rest of an artist's home, there are few examples that can compare to Louise Bourgeois' house in New York.

Bourgeois (1911–2010) was born and grew up in France before moving to New York in 1938 with her husband, the art historian Robert Goldwater. Among her studios was a huge former jeans factory in Brooklyn that still had the lightbulbs that hung over each seamstress as they worked and which Bourgeois used to break up the space. This was where she produced her enormous *Cells* series of installations.

She also had a small basement studio at their Chelsea home, a narrow brownstone townhouse at 347 West 20th Street. But, when her husband died in 1973, she began to expand her working space until the whole home effectively became her studio, leaving only the bedroom she shared with Goldwater and his library untouched as virtual shrines to him. According to the Easton Foundation that oversees her legacy, she was in effect 'transforming the whole house into a work of art'.

Bourgeois worked in a variety of media. Though perhaps best known as a sculptor and installation artist, she also painted, printed and worked in fabric, including her own ripped-up dresses. Since she was something of a hoarder and threw very little away, her house gradually became full of maquettes, sketches and materials (in addition to books, posters and her own sculptures), especially after 2005 when developers took over the Brooklyn studio. The oven was downsized to a two-ring hotplate, and she noted down phone numbers by scribbling them on the walls.

Among her favourite ad-hoc working spaces was the kitchen-cum-sitting room where she worked on a small table; a large pinboard of letters, photographs (of her children, as

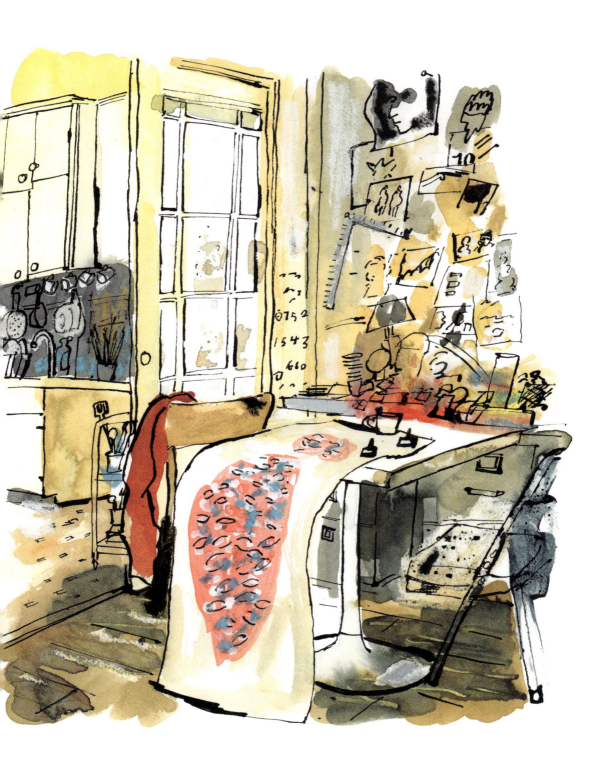

well as Damien Hirst, Tracey Emin — see page 66 — and Bono), postcards, gallery flyers, newspaper clippings and scraps of art jostled for position alongside her. Throughout, there is a decided lack of interest in any kind of welcoming interior décor, piles of books and paper fighting for room among the many used tubes of paint and half-used items of make-up. Jerry Gorovoy, Bourgeois' friend and assistant for 30 years, describes it as 'decrepit splendour', while photographer Jean-François Jaussaud, who took many shots of her in later life, calls it 'her theatre'.

Studio assistants

Behind many great artists are many great studio assistants. Recent examples include Dinos and Jake Chapman who were assistants to Gilbert and George, David Dawson to Lucian Freud, Lauren 'Charlie and Lola' Child to Damien Hirst, and Ashley Hipkin to sculptor Sir Antony Gormley. Isabelle Collin Dufresne was an assistant to both Salvador Dalí and Andy Warhol (see page 180).

One of the earliest was Salaì (full name Gian Giacomo Caprotti da Oreno, 1480–1524) who was Leonardo Da Vinci's assistant as well as something of a muse/model, sitting for *Bacchus*/*St John the Baptist* (painting from da Vinci's drawing by his workshop 1510–15). There may have been a romantic connection between the two — even though Da Vinci called him a thief and liar — but this has not been proven.

The bond between potter Juan Hamilton and Georgia O'Keeffe (see page 138) has also been much discussed, largely because the art world was shocked at the closeness of the relationship between the 27-year-old assistant and the 85-year-old artist, even after Hamilton married.

Some assistants have also become major names themselves. French sculptor Camille Claudel spent a decade as the lover and assistant of Auguste Rodin (see page 158), suffered poor mental health after their split, and spent the last 30 years of her life in an asylum. But since her death her ability has been fully appreciated and she now has a national museum dedicated to her in her home town of Nogent-sur-Seine, in the Aube département.

According to Gorovoy, Bourgeois was a creature of habit. She enjoyed breakfasting on tea and jam (from the jar), and began work with him at 10am (celebrated in her 2006 work *10am is When You Come to Me*; 20 paintings of their hands painted in red, gouached on musical scores). She would work in silence on her sculptural works with a break for lunch, then in the afternoon turn initially to drawing before returning to more physical work.

Bourgeois worked six days a week into her nineties, taking Sunday off when her home-studio became a salon for visiting young artists. These could be quite fraught occasions since the presiding Bourgeois was emotionally erratic and not slow in handing out harsh criticism as well as praise over the several hours of each session. There were only two rules — artists had to bring examples of their work, and nobody could come if they had a cold.

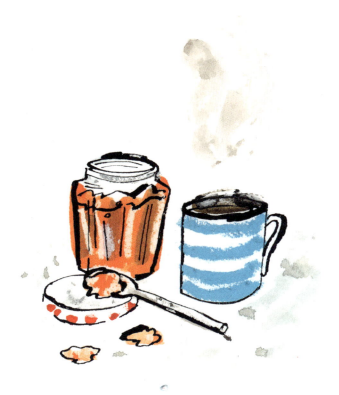

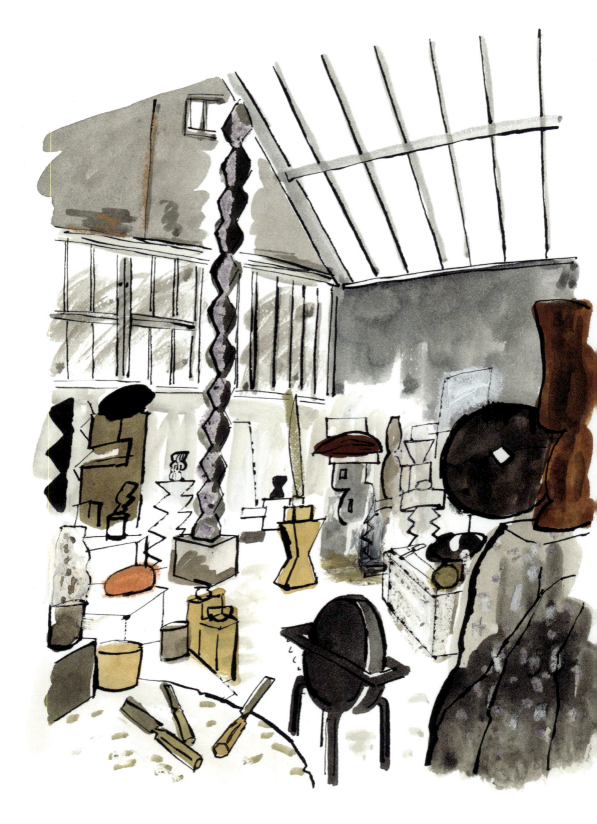

Constantin Brâncusi
Choreographing the studio

11 Impasse Ronsin, Paris, France

Brâncusi's *very* carefully composed space.

Having walked to Paris from his home in Romania to make his name, sculptor and photographer Constantin Brâncusi (1876–1957) lived and worked there from 1904 to 1957, briefly assisting Rodin (see page 158) whom he left because, he argued, 'nothing grows under a great tree'. Brâncusi's Montparnasse studios were at 11 Impasse Ronsin, a street that was home to a thriving artistic community. In his simple, white overalls, white beard and long hair, he echoed the whitewashed walls of the studio around him.

Brâncusi believed the relationship of each piece with the space it inhabited was fundamental to his work and described his arrangements of these works inside the studio as 'mobile groups'. He regularly modified these and eventually focused solely on this, rather than producing more sculptures. If he sold something, he replaced it with a plaster cast to keep the harmony intact. Consequently, the studio itself became a choreographed work of art, documented by Brâncusi himself in photographs.

Barbara Hepworth (see page 74) visited Brâncusi's studio in 1932, noting: 'The quiet, earthbound shapes of human heads or elliptical fish, soaring forms of birds, and the great eternal column of wood.' With its wood shavings and marble dust left untidied, others likened it to a quarry or a monk's cell. Novelist Paul Morand saw it as a cathedral, while photographer Man Ray declared that 'coming into his studio was like entering another world'. He also remarked on a large white plaster cylinder that Brâncusi used as a table and hollowed-out logs that served as seats.

In his will, Brâncusi bequeathed his studio to the French state with the proviso that it be exactly reconstructed. The original studio was demolished in 1961 but visitors to the Centre Pompidou in Paris can enjoy an almost exact replica housing Brâncusi's collection of sculptures, drawings, photographs and paintings, as well as his tools, all behind a glass wall.

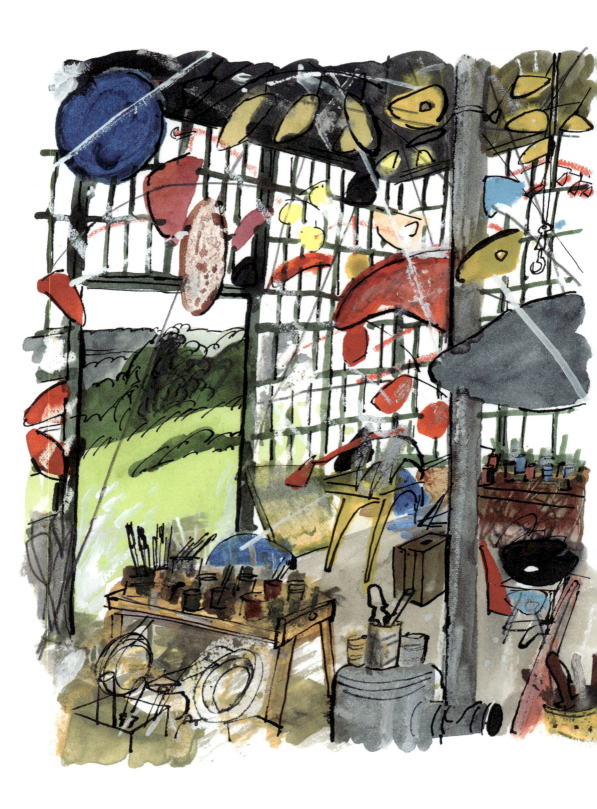

Alexander Calder
A studio for stabiles

Roxbury, Connecticut, USA

Inside Alexander Calder's 'wonderland'.

While his own studios were naturally close to the heart of Alexander Calder (1898–1976), essentially the creator of the mobile as an art form, it was another artist's workplace that played a pivotal role in his life.

An American in Paris from 1926 onwards, Calder experimented in his studio at 7 Villa Brune with his miniature *Cirque Calder*, tiny figures and animals made out of everyday materials such as cloth, metal and cork that were then animated by hand using wire. He put on presentations of this charming performance art in his studio, encouraging visitors to bring their own boxes to sit on, munching on peanuts during the show.

But the next crucial step came in October 1930 when he visited Piet Mondrian's studio in the French capital (see page 126). Rather than being amazed by the paintings, it was the abstract studio environment the Dutch artist had put together that bowled Calder over. He called it a 'very exciting room' with light entering from windows on both sides, coloured rectangles of cardboard stuck on the wall and a Victrola record player painted red. He put it to Mondrian that it would be interesting to make these static rectangles move around. Mondrian was not keen ('It is not necessary,' he replied, 'my painting is already very fast'). But for Calder it provided the spark to do exactly that, going on to begin experiments with abstractly shaped mobiles, the name suggested by artist Marcel Duchamp who visited Calder's studio in Paris the following year.

Calder's major studio was in Roxbury, Connecticut, where he lived from 1933 onwards. More like a warehouse, it was huge and filled to the brim with what might look like clutter to the untrained eye, ranging from shelves full of necklaces to large pieces of sheet metal and abstract shapes hanging on wires from the high ceiling. But to Calder these were the raw ingredients for

what he termed his 'kinetic sculptures' and monumental abstract constructions that he described as 'stabiles'.

Built with concrete blocks, the studio had vast floor-to-ceiling windows that were the ideal home for his mobiles, whether driven by touch or natural air currents. Calder's biographer Jed Perl described the atmosphere inside as a 'wonderland, the air crowded with mobiles and pieces of mobiles' and his friend Peter Bellew compared it to 'attending the rehearsal of a symphony orchestra'.

Built with concrete blocks, the studio had vast floor-to-ceiling windows that were the ideal home for his mobiles, whether driven by touch or natural air currents.

Poet André Massard visited the studio in 1948 and in his poem 'L'Atelier d'Alexander Calder', written afterwards, he talks of 'gigantic dragonflies' and 'little crimson moons' hung from the studio's rafters.

Calder's grandson Alexander Rower has described him as a very social person, but one that was always working, rising early to breakfast on soft-boiled egg with only a break for lunchtime and a nap during his working day. Rower says his grandfather concentrated fiercely in his studio and wanted no noise, music or even an assistant to interrupt him (apart from the sounds of his own mobiles as they gyrated), calling it a 'very silent place, like a sanctuary'.

Julia Margaret Cameron
Swapping chickens for a camera

Dimbola, Isle of Wight, England

Cameron made imaginative use of her outbuildings.

Julia Margaret Cameron (1815–79) was given her first camera on her forty-eighth birthday. At Dimbola, her home on the Isle of Wight, she quickly developed a style of soft-focus portraits, becoming one of few women photographers in a very male industry. And she did it from a most unusual studio.

'I turned my coal-house into my dark room,' she wrote in her 1874 autobiography *Annals of my Glass House*, 'and a glazed fowl-house I had given to my children became my glass house ... the society of hens and chickens was soon changed for that of poets, prophets, painters and lovely maidens, who all in turn have immortalized the humble little farm erection.'

In this former chicken coop, Cameron photographed her friends, often dressed up in elaborate costumes with a hint of family theatricals about them. Among them were scientist Charles Darwin, poet Alfred, Lord Tennyson, novelist Anthony Trollope, astronomer Sir John Herschel and painter George Frederic Watts. Her goal always was to capture emotional personality rather than physical truth. She also staged small group scenes, often with Arthurian, Shakespearean or biblical themes, using members of her household domestic staff (it was felt she employed people whom she believed were photogenic) to depict the Madonna or the infant Christ. Tennyson half-jokingly called her subjects 'victims'. She often asked local villagers to pose for her, too, not to mention tourists she randomly came across.

Although she never ran a commercial studio, she did accept an offer from the South Kensington Museum (later the Victoria & Albert Museum) to use two rooms on their site as a portrait studio, a move that the V&A suggests made her their first artist in residence. After she emigrated to Sri Lanka, Cameron's property was nearly demolished before becoming a museum celebrating her work. Unfortunately, the chicken coop studio has not survived.

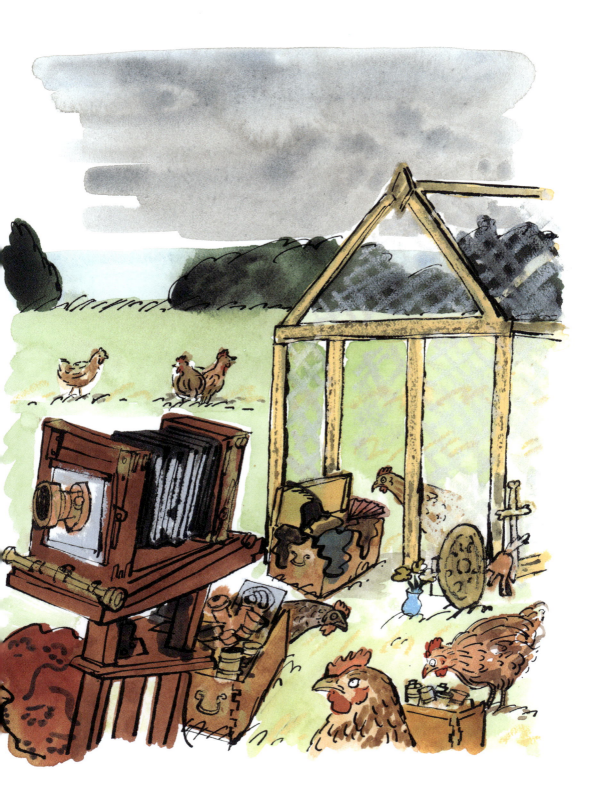

Caravaggio
The dangers of DIY

Vicolo del Divino Amore, Rome, Italy

Caravaggio: not perhaps the ideal tenant.

Known as something of a fighter — indeed he received a death sentence for murder — Italian painter Michelangelo Merisi da Caravaggio (1571–1610) moved around between Milan, Sicily, Naples, Malta and Rome. In the Eternal City, after a spell in prison but still under house arrest, he rented a house in the Campo Marzio area on Vicolo San Biagio (later renamed Vicolo del Divino Amore) from a Prudenzia Bruni. It was over two storeys plus a cellar and had a courtyard at the back.

It is not possible to reconstruct his studio but an inventory of his rooms after he had made a hasty retreat to Genoa following a scuffle shows he had various daggers and swords, furniture (a bed, stools, a chest, two straw chairs, a doorknocker), crockery, clothes, a flask and water jug, a guitar, a violin (although he didn't play), a dozen books (none identified), and of course an easel and various canvases unpainted and painted. He also owned two mirrors, one large (*un specchio grande*) and one convex (*un scudo a specchio*) that he probably used to study his models as he worked.

The property contract shows he had Bruni's permission to remove part of the ceiling. However, he seems to have perhaps gone too far in his DIY, since Ms Bruni took him to court not only for non-payment of rent but also for significant damage to the house, specifically '*un soffito mio di detta casa che esso ha rotto*' or 'a ceiling he has broken in my house'. We will never know for sure what he was up to, but one theory is that he turned his studio into an enormous camera obscura by letting in enough light to project images onto his large canvases.

Research also suggests he used fixative chemicals including light-sensitive mercury salt to produce very early photographic results. David Hockney (see page 80) is among high-profile researchers investigating Caravaggio's use of optic tools, including lenses for foreshortening effects and wider fields of view.

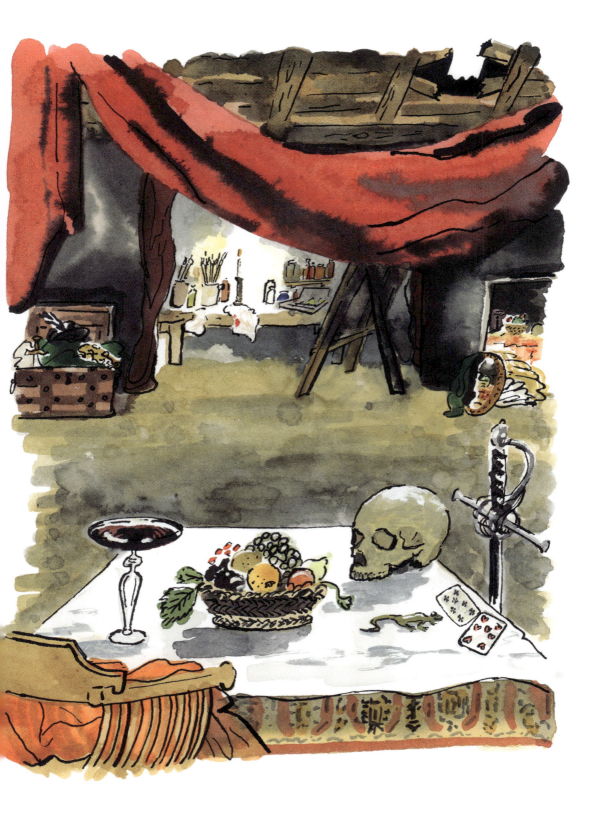

'If a picture seems soulful to the viewer, if it shifts his mind into a beautiful mood, then it has satisfied the first demand of a work of art, however poor it may be in terms of drawing, colour, manner, and so on.'

Caspar David Friedrich

'An artist can show things that other people are terrified of expressing.'

Louise Bourgeois

Paul Cézanne
Neat and tidy vs chaotic disorder

Aix-en-Provence, France

Cézanne's study is neat now, but back then ...

'I have a large studio in the country,' Paul Cézanne (1839—1906) wrote to the art dealer Ambroise Vollard in 1903. 'I can work better there than in the city.'

The atelier just outside Aix-en-Provence in the south of France where the French painter worked from 1902 until his death is in a lovely spot, with large, naturalistic gardens, but would have been even more idyllic 120 years ago before the suburbs reached it. Just outside the city and looking out onto an olive grove, it gave Cézanne a marvellous view of the Montagne Sainte-Victoire that featured in many of his paintings.

His purpose-built studio on the upper floor of the building he built on land he bought in 1901 is one of those 'just popped out for a moment' museums that has kept things exactly as they were in the artist's lifetime. His original easel and palette, smock and hat, bottles, pottery, cupid plaster cast, notebook, pipe, walking stick, three human skulls, and a tall ladder are all still here. However, the prominent display of his inspirational apples is refreshed regularly.

The bright space is illuminated by a glass roof and enormous floor-to-ceiling window facing north, though Cézanne complained of green reflections from the olive trees. In the floor is a kind of slot that he used to move his larger canvases such as *Les Grandes Baigneuses* (1898), his final exploration of the bathers theme, in and out of the studio.

Although the ground floor had a sitting room space, kitchen and bathroom, Cézanne ended up using it as storage space since he lived in town and walked up to his studio to work every day, usually from early in the morning, around 6am, until 5pm, with a break for lunch back home. If the weather was good, he also worked outside up the Lauves hill where the farmhouse was built.

Today, the roughly 8 x 7 x 7m (26 x 23 x 23ft) studio space looks remarkably neat and tidy but when critics R.P. Rivière and Jacques Schnerb visited in 1905, they reported piles of canvases in every corner, rolled and on stretchers, and in general 'chaotic disorder', with paintings simply left on chairs, lunch leftovers used for still life inspiration hanging around and brushes thick with dried paint. Jules Borély, another painter, noted a couple of easel paintings as well as several apparently just thrown on the floor, and the French writer Joachim Gasquet described the atelier as virtually empty apart from an easel, stool, a chair for sitters and a stove.

His original easel and palette, smock and hat, bottles, pottery, cupid plaster cast, notebook, pipe, walking stick, three human skulls, and a tall ladder are all still here.

Cézanne mixed the paint for the walls himself; grey with a touch of green. Gasquet said the light made the walls slightly blue, which photographer Joel Meyerowitz has argued made the objects he depicted stand out and enabled Cézanne to produce the 'flatness' that characterized his work. Although the walls were largely empty, painter and writer Émile Bernard noted a landscape of Aix and a study of skulls when he visited. Bernard also sat for a portrait and enraged Cézanne by moving — 'You must be as quiet as an apple, an apple that never moves' he scolded him.

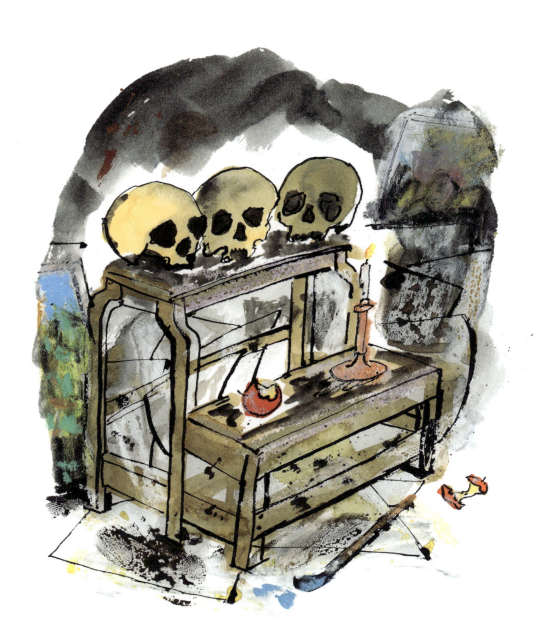

Marc Chagall
Twenty-four months in the country

High Falls, Catskills, New York, USA

Marc Chagall's nice quiet spot for work.

Marc Chagall (1887—1985) was born in Vitebsk, in what is now Belarus, and he spent a large part of his early working life in Russia and France. In Paris in 1912, he took a studio in La Ruche, the famous three-storey block of ateliers favoured by many artists, in particular those from Eastern Europe. Designed by Gustav Eiffel with a cylindrical shape and a labyrinthine interior (*la ruche* means 'beehive'), it was owned by French sculptor Alfred Boucher. He turned it into a working colony for Paris-based artists such as Modigliani and Brâncusi (see pages 122 and 32). Chagall's remarkable *Paris par la fenêtre* (Paris Through the Window, 1913) documents the view he had from his studio over the city towards the Eiffel Tower.

Escaping invading Nazi forces, Chagall headed to the USA. In his autobiography *Ma Vie* (1923), he wrote that while his wife preferred the glitz of Manhattan, he was quite satisfied with a 'secluded nook' where he could sit beside a river and paint. For two years, he found exactly that at High Falls in the Catskills Mountains.

The move was precipitated by his wife Bella's sudden death from a viral infection in 1944 and the depression Chagall endured as a result. Looking for somewhere to recover, he was delighted to be shown a property on Mohonk Road in High Falls that reminded him of the traditional homes in his much-missed Vitebsk.

Now, it is a two-bedroom cabin, but back then it was a farmhouse and separate 255m² (2,745 sq ft) studio building. Chagall had larger windows put in, but these have since been replaced. Initially on the market for $240,000, it was eventually sold in 2023 for $205,000, including tiled mudroom (boot room), original wood flooring and beams, and internal wooden shingle walls, as well as a kitchen and upstairs bedroom. The adjoining grounds also inspired a number of his works including *Les Amoureux aux Coquelicots* (*Deux Bouquets à High Falls*) (1948—52).

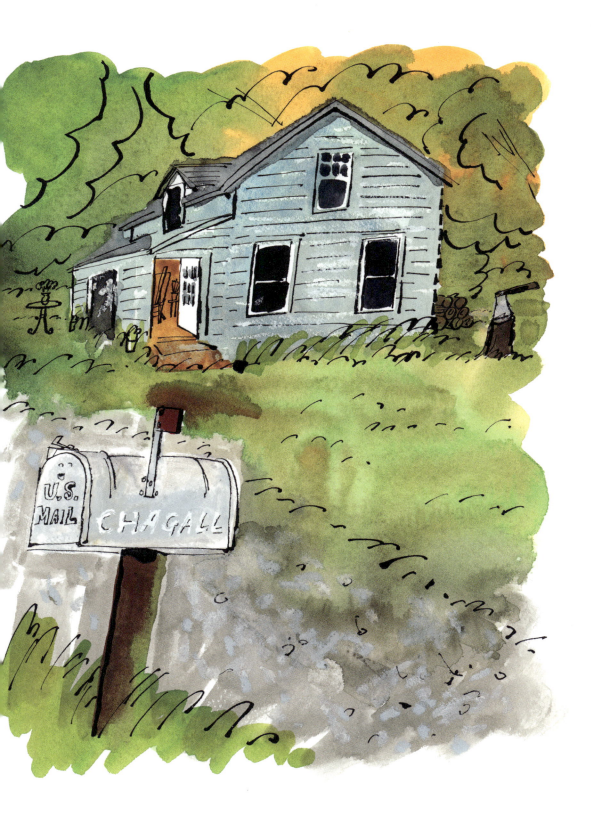

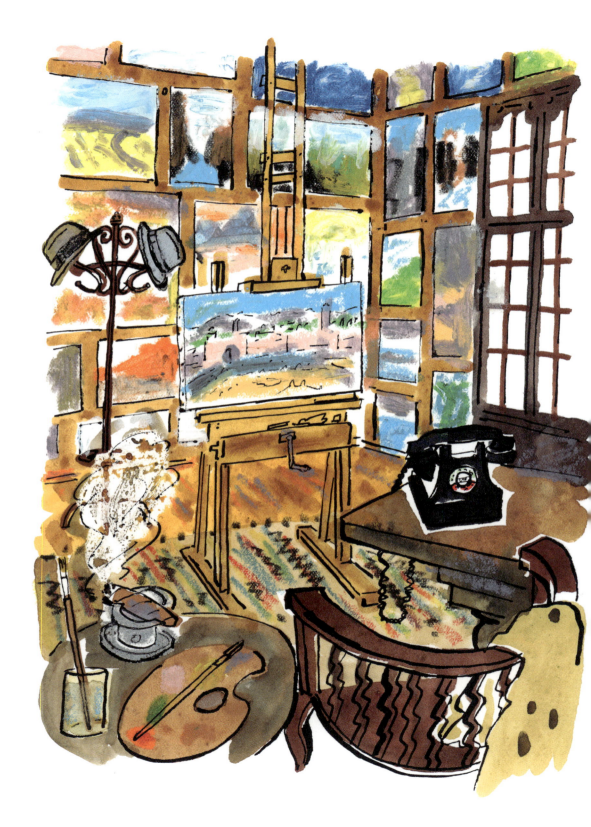

Winston Churchill
En plein air with bodyguards

Chartwell, Kent, England

Churchill: an amateur painter with a distinctive method.

More famous as a politician and writer, Winston Churchill (1874–1965) was also a keen painter, although he only started once he was in his forties in the aftermath of the disastrous First World War Gallipoli campaign that he oversaw. This did not prevent him from producing more than 500 paintings in the second half of his life and his *Tower of Koutoubia Mosque* (1943) was sold by Christie's at auction in 2021 for just under £8.3m.

Churchill was not trained and was dismissive of his own paintings (as, to be honest, are some art critics), referring to them as 'daubs' and the process as 'a joy ride in a paintbox' by a 'week-end and holiday amateur'. He often gave them away — *Tower of Koutoubia Mosque* was originally a present to US President Franklin D. Roosevelt.

However, he did acknowledge that painting helped him deal with stress and as a therapy for his regular bouts of depression. 'Painting is a friend who makes no undue demands,' he wrote in his 1922 essay 'Painting as a Pastime', 'excites to no exhausting pursuits, keeps faithful pace even with feeble steps, and holds her canvas as a screen between us and the envious eyes of Time or the surly advance of Decrepitude.' Sir John Rothenstein, head of the Tate Gallery from 1938 to 1964, said that Churchill once told him: 'If it weren't for painting I couldn't live. I couldn't bear the strain of things.' Interestingly, for such a talkative man, he always painted in silence.

Initially a watercolourist, he quickly moved on to oils (most of his painting gear obtained from Roberson's, the artists' supplier in London's Long Acre), constantly asking for advice and lessons from professional artists such as Walter Sickert, Sir John Lavery and Sir William Nicholson, as well as copying work by artists such as Claude Monet, Charles-François Daubigny and John Singer Sargent. Indeed, it was Sickert who showed him

how to work from photographs, particularly as aide-mémoires, a technique that Churchill fully took on board. He used them regularly to help with his paintings in his studio at his Chartwell home in Kent, now cared for by the National Trust.

Churchill built some of this brick studio himself and became quite a dab hand at bricklaying to the point where he rather surprisingly joined the Amalgamated Union of Building Trade Workers. He also enjoyed working in the open air, initially during the First World War on the western front in Flanders, but also on his travels around the world, including a trip to the pyramids in Cairo with T.E. Lawrence, and during various world conferences.

He painted many pictures of the exterior of Chartwell and during the 1950s always travelled with his painting apparatus. This was usually carried by his bodyguards Edmund Murray (himself a very good oil painter) and Ronald Golding, who said that it was 'sometimes rather a pantomime' as Churchill, wearing his customary white painting smock, arranged his seat and table at a picturesque location with cleaning rags, turpentine and brushes to hand.

Golding also described how the plein air-studio arrangement worked. Back at Chartwell, Churchill would set up one of

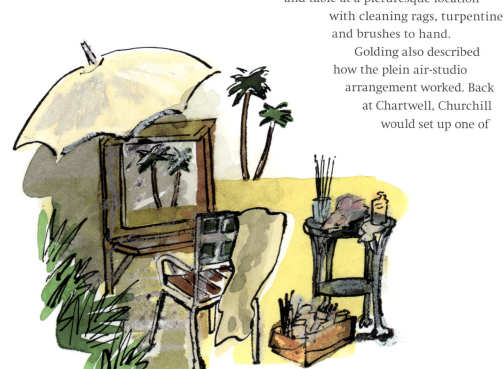

his partly painted canvases in his studio, then insert a slide of the photograph taken at the original site into an 'old fashioned magic lantern'. He then adjusted the projected image until it matched the size of the canvas and fell in the right place onto the uncompleted painting, and thus guided would then continue to work on it.

Today, the studio at Chartwell holds the largest collection of Churchill's paintings, almost all landscapes and still lifes, laid out with his easel centre-stage as if he were still working there. Recent restoration work has reintroduced the original wooden-grid system that Churchill had fitted to display his usually very colourful work.

Prisoners of war

Artists, like those in any other profession, have always fought in wars. A special volunteer corps of the British Army was even set up in 1860 called the Artists Rifles whose founding members included Frederick Leighton, George Frederick Watts, William Morris (who often mixed up his left and right while marching) and Dante Gabriel Rossetti. The regiment fought in the Boer Wars. Artist brothers Paul and John Nash were among those who signed up during the First World War.

Some artist soldiers were, of course, captured. Canadian artist Arthur Nantel (1874–1948) enlisted in 1914 and painted the first day of the Second Battle of Ypres in 1915. He was captured that year and spent the rest of the war at the Giessen prison of war camp near Frankfurt. In the early part of the war Giessen housed several artists, including French officer Raphaël Drouart (1894–1972), and they were offered the use of a small shed-studio where they could work on their portraits and scenes of camp life. They painted on canvases but also whatever came to hand, including ration tin lids.

Something similar was run at the Hutchinson Camp on the Isle of Man during the Second World War, which became known as 'the artists' camp'. German artist Kurt Schwitters (1887–1948) was among numerous internees and was allowed a small studio space where he also taught fellow captives and produced 200 works over his year and a half in detention. The camp even held art exhibitions, although inmates often had to be resourceful in making their own supplies, mixing brick dust and sardine-can oil to create a kind of paint, and cannibalizing linoleum floors to make linocuts.

Leonardo da Vinci
Team painting

Florence, Italy

Leonardo advocated order and dignity in a studio.

Leonardo da Vinci (1452–1519) had strong views on artists' workplace surroundings. 'Small rooms discipline the mind,' he argued in one section of his surviving notebooks, 'large ones weaken it.' He also urged painters to avoid light that cast a dark shadow, and suggested that on sunny days they paint subjects in a courtyard with tall walls painted black and covered with a linen awning. This preoccupation with light extended to a series of drawings indicating the best type of window to install depending on a room's situation.

For Leonardo there was also a distinction between the working surroundings of the painter and the sculptor. The *paragone* (meaning 'comparison') debate was an ongoing Renaissance discussion that pondered which was the higher form of art. While Michelangelo (see page 112) saw positives in both sculpture and painting, Leonardo was very much in the painting camp.

Sculptors, Leonardo wrote, generate sweat and dust that cakes everything in mud, from the sculptor's face to his room making it dirty and unappealing, not to mention the constant loud hammering noise. He compared this to a painter's set-up, sitting comfortably and finely dressed, gently using a brush, surrounded by pleasant music and in a nice clean home full of charming paintings. Leonardo emphasizes that painters should avoid disruption and distraction. He may also have used some kind of drawing machine to help with perspective as the earliest representation of one is among his notes, dating from around 1480.

Identifying a specific location for any of Leonardo's studios is difficult. In 2005, a workshop apparently used by him for fresco work was discovered in the Santissima Annunziata basilica in Florence. A fairly free recreation of what his bottega might have looked like has also been attempted at the Château of Le Clos Lucé in France where he worked at the end of his life.

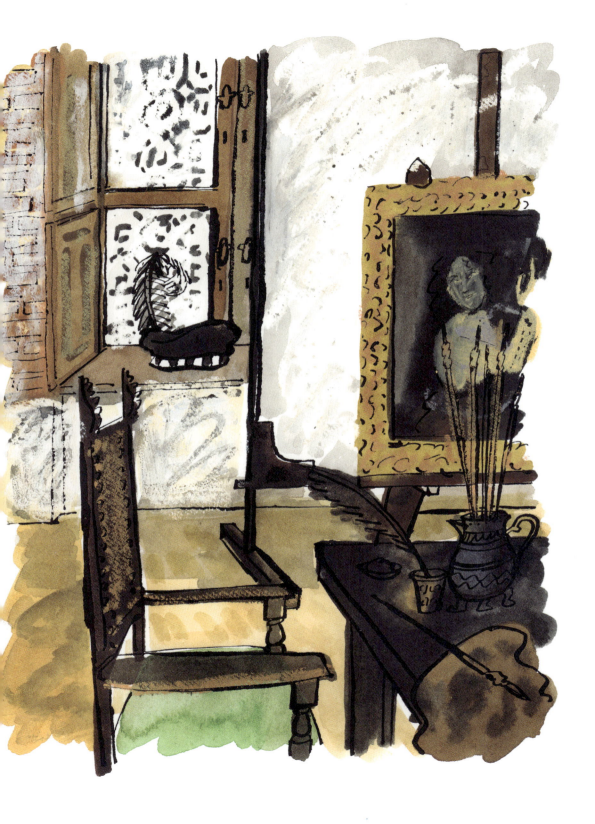

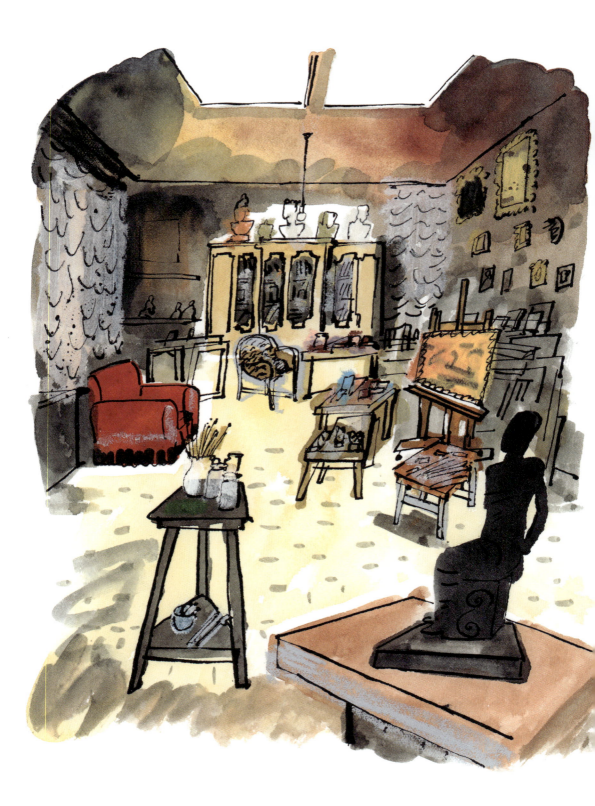

Giorgio de Chirico
Making a metaphysician's studio: Part I

Various studios, Paris (France) and Rome (Italy)

The studio where Giorgio de Chirico explored the life of the mind.

Pablo Picasso's standing influenced Italian artist Giorgio de Chirico's decision in 1913 to take a studio in Montparnasse, close to the Spaniard's home and thus his avant-garde artistic circle. It was also near that of the poet and art critic Guillaume Apollinaire. It was his write-up of an exhibition of paintings by de Chirico (1888—1978) in his studio at 115 rue Notre Dame des Champs that helped make his name. Apollinaire praised his work as uniquely original 'inner, cerebral art' that owed nothing to Picasso or other recently discovered artists, and as a result leading art dealer Paul Guillaume took him under his wing.

De Chirico's later studios included one at 9 rue Campagne-Première. In his 1918 prose poem 'Zeuxis the Explorer' he describes it as his 'squalid atelier' where he was starting to develop his metaphysical brand of surrealism. He also left many of his paintings here when he enlisted in the Italian army in 1915. De Chirico returned to Paris after the war but was briefly so down on his luck that he had to give up his studio; when the landlord prevented him from entering, he asked a friend to help him break in through the window to retrieve his paintings.

Studio-sized spaces or 'metaphysical interiors' were constant features in his work, as likely to include arched arcades as canvas stretchers. In a 1919 article 'We metaphysicians' he talks about the metaphysician's studio as being a mix of 'astronomical observatory, finance office, and portolano [sailing chart] cabin', with just enough canvas to 'create the perfect work'.

His second-floor apartment-studio in Rome at Piazza di Spagna No. 31 is now open to the public, with a large skylight and his brushes, easel, tools and reference books all on display. Like René Magritte (see page 108), it's a remarkably unremarkable workplace for someone whose intention was to depict a psychological world beyond its physical reality.

Eugène Delacroix
A simple workshop

Rue Notre-Dame-de-Lorette, Paris, France

Delacroix liked to 'get out of the dust of the studio'.

Although best known for his paintings, French Romantic artist Eugène Delacroix (1798—1863) also kept a wonderfully detailed journal, mainly in five small notebooks (including one he left behind in a cab in 1848 and lost forever) and several sketchbooks. These cover his thoughts on everything from his philosophical musings to discussions of the work of Michelangelo and Mozart. What also loomed large in his daily observations were his studios.

'The studio is totally empty,' he notes in December 1857 of leaving his studio on Rue Notre-Dame-de-Lorette. 'This place, which surrounded me with all sorts of paintings, several of which pleased me by their variety, and which all awakened in me a memory or an emotion, still pleases me in its solitude.'

This large studio was pictured in an engraving by Edward Renard in 1852 that shows Delacroix in the middle of the barn-like structure talking to a client with other visitors perusing the many works of his that are positioned throughout the space. It is also where the critic Augustin-Joseph Du Pays visited him in his series on contemporary artists' studios for the magazine *L'Illustration* in the 1850s. He describes it as a 'simple workshop … the walls are covered with paintings and sketches and among these paintings it is not surprising that we see a copy executed by the artist himself after Raphael' — he is obviously disappointed that, given Delacroix's slightly bohemian reputation, it isn't more sumptuous. The artist did, however, find room for a large chest of various objects he brought back from a trip to Morocco in 1932, including pottery, slippers and various items of clothing.

Eight days later he seems to have got over leaving the Rue Notre-Dame-de-Lorette studio behind and is rejoicing in his new, indeed his final, studio at 6 rue de Furstenberg, which he chose because it was closer to the church of Saint-Sulpice where he was working on murals of *Jacob Wrestling with the Angel* and

Heliodorus Driven from the Temple (both 1854—61). 'My new place is charming,' he writes. 'The sight of my little garden and the cheerful aspect of my studio always makes me happy.'

Most of the comments about his studios are a little more pedestrian ('I got up early this morning and went immediately to the studio: it was not yet seven o'clock', 26 April 1824) and often recount who visited his atelier on that day. But others are more reflective. Here he is in March 1852: 'One ought to go out every day before dinner, dress, see one's friends, and get out of the dust of the studio.'

> *'This place, which surrounded me with all sorts of paintings, several of which pleased me by their variety, and which all awakened in me a memory or an emotion, still pleases me in its solitude.'*

This studio he designed and built with a neo-classical façade and a large central window in his private garden — now all part of an artist museum dedicated to his work after it was saved from plans to demolish it and replace it with a garage — was decorated with Greek bas-reliefs, and he notes in his journal for May 1857 the cost of buying and delivering these. While he did invite some friends and colleagues here, not everybody was welcome. Claude Monet (see page 128) was eager to meet him but was refused entry to the studio and had instead to watch the master at work through the windows of his Impressionist artist friend Frédéric Bazille's nearby studio apartment, which overlooked Delacroix's.

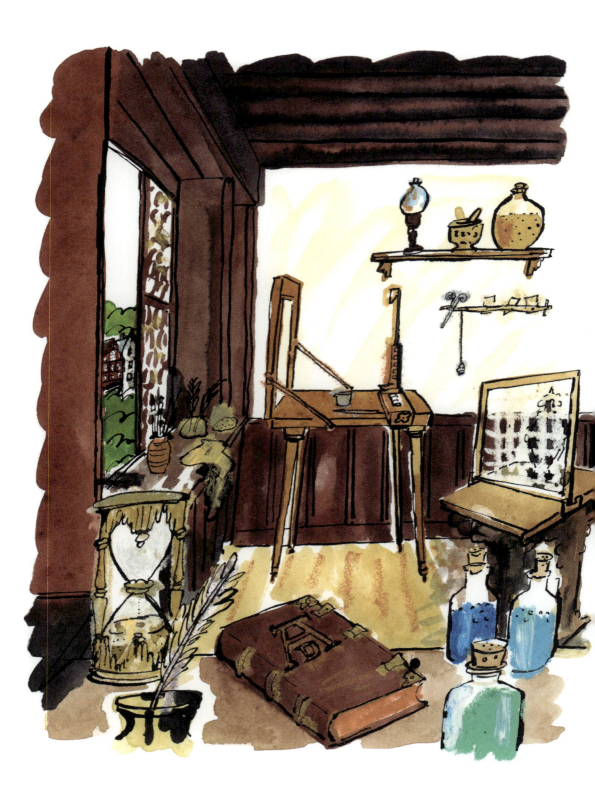

Albrecht Dürer
The modern idea of the studio

Nuremberg, Germany

It's likely that Dürer used a grid frame in his studio.

It isn't possible to point to 'The First Artist's Studio'. Early craftsmen worked in fairly public communal workshops before gradually moving towards more private, individual spaces. An early example of this comes in *Il libro dell'arte* (The Book of Art) written around 1400 by Italian painter Cennino Cennini. He talks about the importance of a *studietto*, a little study where an artist can work without interruption, with a desk beneath a window — the kind of workplace more normally associated with a literary scholar.

In a more philosophical sense, art critics Jeffrey Weiss and Peter Parshall have argued that the much-analyzed *Melencolia I* (1514) by German woodcut printer, engraver, goldsmith and painter Albrecht Dürer (1471–1528) marks 'the emergence of the modern idea of the studio' as a place where an artist works in seclusion.

The engraving depicts a pensive, winged female figure, seated and surrounded by various objects related to time and measurement technology (hourglass, sundial, compasses, various mathematical grids and forms), plus tools (saw, plane, hammer, nails) and equipment for creative production, such as a crucible and inkpot. Although the theme is melancholy in general and certainly not a depiction of Dürer's own workplace (for example, there are no brushes or canvases pictured), Weiss and Parshall suggest that: 'this figure of a maker/thinker surrounded by tools, instruments, and other objects … might also be considered as the earliest fully theorized image of the studio in Western art … a notional image of the workshop as a metaphor of the artist's mind.' It can also be read as an exploration of how working routines were becoming more regulated.

From 1495, Dürer set up his own workshop for making prints and painting and there have been imaginative reconstructions of Dürer's studio in the 500 years since his death including a very

atmospheric if entirely speculative painting by the nineteenth-century French artist Louis Charles Auguste Steinheil. The actual space has not survived the ages, though some critics argue that a reflection in the eye of his 1502 watercolour *Young Hare* reveals the window frame in his studio.

An unproven tradition has it that Dürer worked in a dormer room on the top floor of the house in Nuremberg that he bought in 1509 and today operates as an artist museum dedicated to his life and work. Installed here is a conjectural reconstruction of what his studio might have looked like, and visitors can enjoy a glimpse into the working life of an artist in that period.

Dürer was also intensely interested in the theory and practice of art and wrote on the subject as well as building his own perspective machines to help artists draw accurate images of objects and people. Woodcuts of these are included in his 1525 treatise *The Painter's Manual: A manual of measurement of lines, areas, and solids by means of compass and ruler* including a portable contraption, and shown in a studio are others that help with the drawing of a lute, a jar and a reclining naked female model, who is shown being sketched with the aid of a grid frame. It seems likely that one of these machines would have been in his own studio.

Dürer was also intensely interested in the theory and practice of art and wrote on the subject as well as building his own perspective machines to help artists draw accurate images of objects and people.

Dürer was an inveterate traveller and worked on the road in many different working spaces. He was also a keen collector of anything that took his fancy along the way — among his possessions were a chalk drawing of three nude man sent to him personally by Raphael, ivory salt cellars and an ivory whistle, various bits of coral, a large tortoise shell and a number of animal horns. Where in his house he kept these and many other curiosities — in addition to a personal library of books — is unknown, but there is some speculation that he kept some of them in his studio.

Tracey Emin
From studio to arts district

Union Crescent, Margate, Kent, England

Emin: not just a studio, a whole arts district.

Although she was brought up in Margate, for many years visual artist Dame Tracey Emin (1963—present) lived and worked in London, one of the bright stars of the Young British Artists group in the 1980s and 1990s.

But in 2016, when planners decided to turn down Emin's planning application to expand her studio in Spitalfields (which would have involved demolishing a 1920s building), rather than appeal and battle against local conservation groups, she decided to look elsewhere. In the end, she decided to return to Margate, the place she says is 'part of my DNA, part of my thoughts'. Indeed, Emin is not the only artist to think so highly of the Margate area. 'The skies over Thanet,' wrote J.M.W. Turner, another aficionado, 'are the loveliest in all Europe.'

Back in the Kent seaside town, she bought property on the former site of publishers Eyre & Spottiswoode's Thanet Press printworks in Union Crescent to turn into a studio/living space. She even purchased the former Margate Constitutional Club overlooking her studio to prevent it becoming a nightclub and interfering with her work.

Emin's new Margate studio is a huge, vaulted space but, very like her early studio at the Rag Factory in London's Brick Lane, it has white walls, plenty of windows and an open, airy feel. In a video post on Instagram on 21 August 2021 — which revealed large canvases leaning against the walls and a sparsely furnished space with a rocking chair and a small table — she said this was the first day she would be starting work in

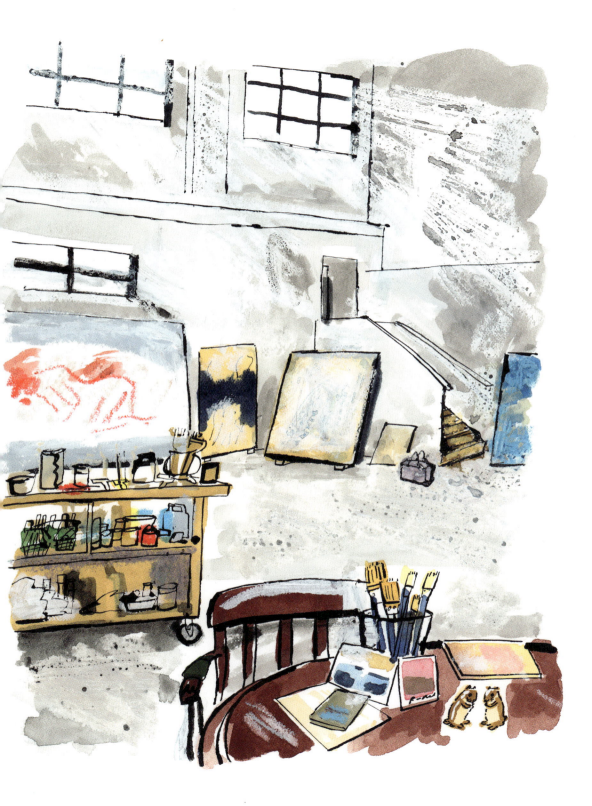

the David Chipperfield-designed workspace after nearly five years of refurbishment. 'I couldn't leave Margate,' she wrote, 'I couldn't let of go of what I truly loved', adding that she hoped it would become a museum for her work after her death.

The work has been given the blessing of the Margate Civic Trust that in 2023 awarded its prestigious Blue Plaque to the building, saying: 'It has been beautifully renovated, using an exemplary choice of materials and fits perfectly into the street scene.'

However, her studio is only one part of a much more ambitious artistic plan for Margate. In the same way that Eyre & Spottiswoode's move sparked the development of other industries associated with printing, Emin's plan is to turn twenty-first-century Margate into an arts district. In particular, in a former

Victorian bathhouse close to her own studio, she has established TKE Studios (a reference to her full name, Tracey Karima Emin), a new kind of art school that offers subsidized studio spaces to a dozen professional artists, as well as offering local and incoming art students free tuition and gallery opportunities. All this sits alongside the Turner Contemporary art gallery that has been in Margate since 2011, while notable curator Carl Freedman's eponymous contemporary art gallery adjoins Emin's studio.

At the opening ceremony she described Margate as a 'creative Mecca' and that she wanted to see it become 'more creative and more available for creative people to live here'. Plans for other buildings, including the town's historic Westbrook Loggia, include cafés, saunas, restaurants and a new community bathers club.

Artemisia Gentileschi
The spirit of Caesar in the soul of a woman

Various studios, Florence, Italy

Gentileschi understood the importance of making a good first impression.

Virginia Woolf wrote about how important it was for creative women to have a 'room of their own'. Though Artemisia Gentileschi (1593—c.1656) was subject to the restrictive conditions of being a female artist in the seventeenth century — ineligible to join guilds, unable to become an apprentice, limited access to certain buildings, legal and business restrictions — one thing she did have access to was a studio.

As the daughter of a successful painter, Artemisia grew up within the working environment of her father Orazio's workshop. Indeed, he recognized her ability from an early age and told his patron, the Grand Duchess of Tuscany, in 1612 that (even allowing for proud-parent bias) she 'has in three years become so skilled that I can venture to say that today she has no peer.'

Artemisia was obviously strong minded. She put fearless women centre-stage in her paintings, giving the subject matter a strong female perspective. This is seen in probably her best-known work *Judith Slaying Holofernes* (1614—20) and the story of *Susanna and the Elders* (1610), which depicts the story of sexual violence from Susanna's point of view; particularly significant for Artemisia who as a young woman was raped by one of the painters in her father's workshop team.

Very little is known about her own workspaces. She married another painter, Pierantonio Stiattesi, soon after her rapist was found guilty, and the couple moved to Florence where her dowry arrangements allowed her to set up her own working studio. It appears that this first workplace was in her father-in-law's house on Via Santa Reparata where he worked as a tailor. An invoice from a carpenter in 1614 shows her studio was up and running, ordering painting stretchers. By 1616 she had moved out and established her own independent workshop on Borgo Ognissanti.

Although it's hard to pin down exactly how her studio looked, Artemisia was always keen on making a good impression and appears to have used some of her own fine gowns as props for paintings. Similarly, letters from the time indicate the decoration of her house was impressive, important when conducting business with potential buyers — luxury possessions included copper kitchenware and gold-embossed leather wall coverings. She described her home as fit for a gentleman to be seen in.

Her business certainly thrived, not least because she was excellent at selling her abilities. 'You will find the spirit of Caesar in the soul of a woman,' she once assured a patron about her quality, and did not shy away from her gender. 'A woman's name raises doubts until her work is seen,' she told her patron Antonio Ruffo, 'I will show Your Illustrious Lordship what a woman can do.'

Her letters give an insight into the day-to-day issues involved in studio work. In another letter to Ruffo, she points out in reference to a commission that nude female models are expensive 'which is a big headache' and that they rip her off and are annoyingly petty.

Artemisia became the first woman to become a member of the Accademia di Arte del Disegno in Florence, developing an impressive spread of patrons across Europe, including the ruling Medici. She later relocated to Naples where again she built up a thriving workshop, which included her own painter daughter Palmira/Prudentia. So collaborative was she that it has made attributing her name to works a problematic job centuries later.

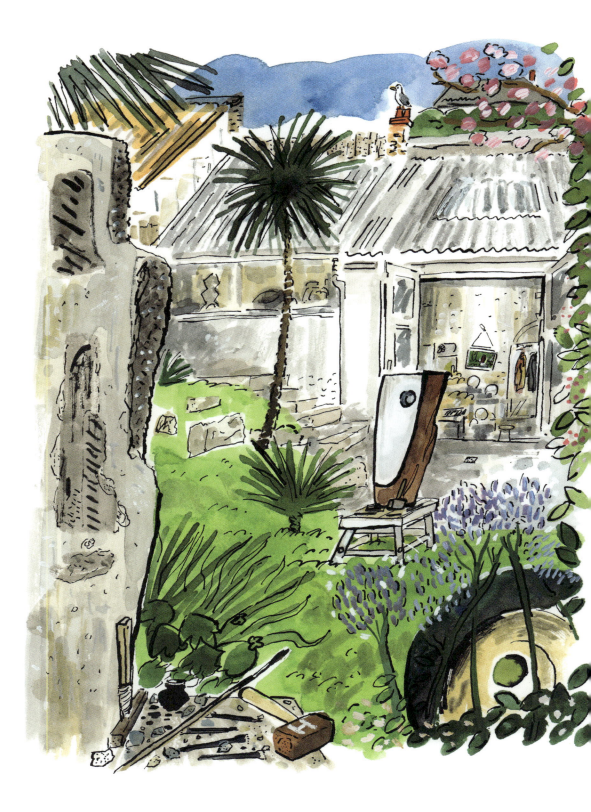

Barbara Hepworth
Create, cook, create, repeat

Trewyn Studio, St Ives, Cornwall, England

Barbara Hepworth's beautiful garden in St Ives.

Sculptor Barbara Hepworth (1903—75) had a series of studios over her lifetime. But even her earliest working spaces in London, shared with first husband and fellow sculptor John Skeaping, shared striking elements with what would become her most famous studio in St Ives in Cornwall. In homes in Belsize Park she worked on a large scale in the garden as well as running an elegantly simple studio.

Creativity in the widest sense continued to play a key part in Hepworth's art throughout her life. In *A Pictorial Autobiography* (1970) she confides, 'I detest a day of no work, no music, no poetry.' A proficient pianist, listening to music was part of her usual working day and she always felt 'the need for dancing', which she linked to the physicality of carving as a means of expression.

She also believed her work and her private life were intertwined, that the ups and downs of day-to-day parenting enriched her art. The key thing though, she emphasized, as effectively a single mother of four children, was that however much time cooking and childcare took up it was important to work every day, even if only for half an hour. In a 1939 letter to the art critic E.H. Ramsden, she talks about how she would 'create' for 30 minutes, cook for 40 minutes, then go back to an hour with the kids, and so on throughout the day.

From 1949 onwards, she bought and worked in the Trewyn Studio in St Ives, a former shed-storage building that became her studio, workshop and home for a quarter of a century. 'It is completely perfect for me,' she said. 'Finding Trewyn Studio was a sort of magic. Here was a studio, a yard and garden where I could work in open air and space.'

A dozen years after buying Trewyn, she also bought the town's former dancehall and cinema across the road, the Palais de Danse, which she turned into a larger studio and worked on huge pieces,

including her largest work, the 6.4m (21ft) *Single Form* (1961—64) that now stands in the United Nations Plaza in New York — the rough grid she scratched into the floor as part of her plans for the piece is still visible. In here she placed her sculptures on plinths with rubber castors so she could move them around and see how they related to each other in differing positions.

After her death in an accidental fire in the studio in 1975, the property was turned into the Barbara Hepworth Museum and Sculpture Garden, the artist's house that she had hoped it would become, and was given to the Tate in 1980. Today, it is the home of the largest permanent display of Hepworth's works, in the place they were created, and in fact in the positions where Hepworth herself placed them.

In here she placed her sculptures on plinths with rubber castors so she could move them around and see how they related to each other in differing positions.

The stone-carving studio and the plaster studio offer a marvellous insight into her working atmosphere and give it a distinctly non-museum feel. After she died, her tools, benches, paints, materials and unfinished/uncut pieces were left largely untouched and as she left them, and the guiding rule has been that everything there now had been there at some point during Hepworth's life. Conservators treat the tools to prevent their deterioration while still preserving the marble dust and plaster that remain stuck to them. Personal items on show including work clothing are similarly cared for.

The garden that influenced her work and where Hepworth worked as often as she could (she also occasionally snoozed in the white summerhouse) has also been well preserved. Recently, the huge sculpture *Four-Square (Walk Through)* (1966) has been conserved after decades of weathering took its toll on the surface.

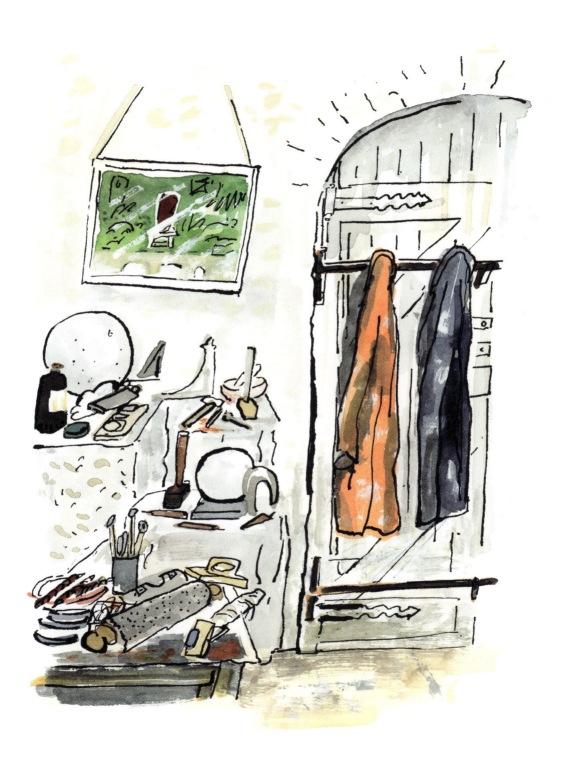

'Every artist was first an amateur.'

Ralph Waldo Emerson

'I paint them because they're cheaper than models and they don't move.'

*Georgia O'Keeffe,
on her flower paintings*

David Hockney
'Plan to be spontaneous'

Various studios in London and Yorkshire (England) and Los Angeles (USA)

An early start in East Yorkshire for David Hockney.

As a young artist David Hockney (1937–present) lived in a large, five-windowed studio flat in a slightly insalubrious area of London's Notting Hill. 'The room suited him simply because it was big enough for him to work and think in,' *House & Garden* magazine commented in a profile of him in 1969, 'cool and spacious, ideal for an artist little concerned with … any of the more conventional self-awarded trappings of success.' In later life, he has commented that life in London offered too many easy distractions to his work.

Hockney returned to his native Yorkshire to spend a long period in the late 1990s and 2000s, enjoying painting *en plein air* in East Yorkshire and spending barely any time working in the studio. It was also a perfect example of how his maxim 'plan to be spontaneous' worked in practice. Logistics were carefully thought out: adapting a 4 x 4-vehicle to fit in art materials and canvases, scheduling painting sessions for mornings and evenings when the light and shadow was most interesting, and researching locations properly for their appeal. But the approach was very fluid; aiming to finish a canvas on the day he started, but, when this proved impossible, continuing with it when conditions were suitable again, which could mean he would be working on a number of paintings at one time. The end of May was a particularly favourite time of the year, when the hawthorn was out; he would often start work at 5.30am, head back to bed at midday for a siesta, then return to work outside for the evening shift.

In recent years, largely because of his increasing deafness, he goes out very little and has described his daily routine as largely 'painting, reading, and a few nights of nice sex'. While painting in Yorkshire, he would bring his canvases down from his studio and place them on the wall of his bedroom so that he could see them last thing at night and first thing in the morning

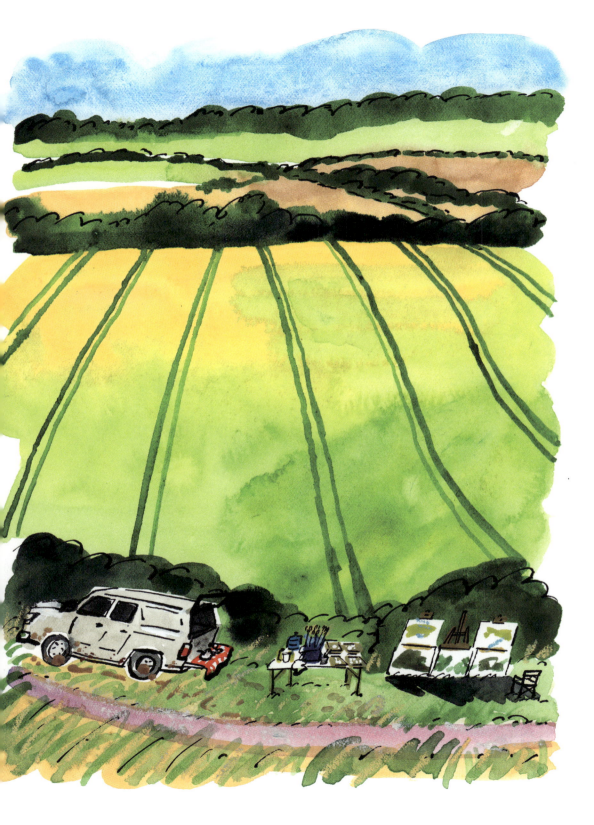

82 David Hockney

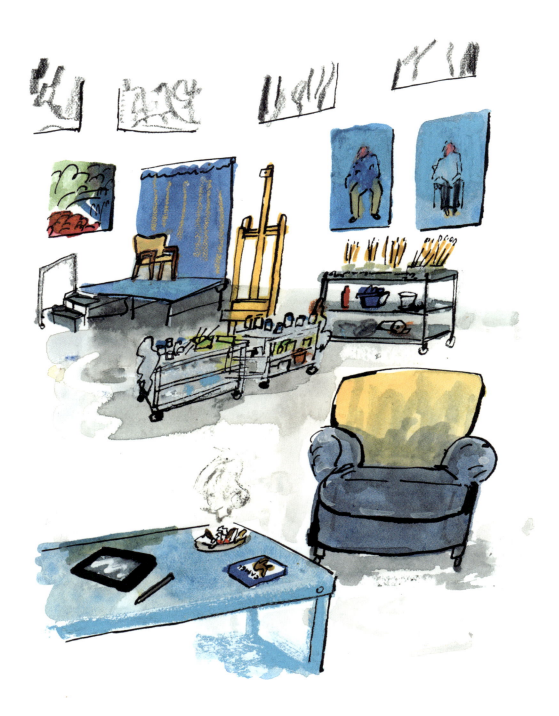

in preparation for what to do next. He described this method as 'like living in the studio'. In more recent years this approach has become more hi-tech, storing images of his current work on his iPad that he takes to bed with him.

Bruno Wollheim, the filmmaker who produced the documentary *David Hockney: A Bigger Picture* (2009) describes this approach as 'an exhausting Calvinist work ethic'. Yet Hockney says he spends so much time in there because he loves his work. 'If any artist tells you he's not having fun in his studio, there is something wrong with him,' he says. Now in his eighties, he comments that he feels 50 years younger when he's in the studio, which is why his studio is like a second home. It's an echo of Picasso's comment on nearing 90 that, 'I have decided to remain 30.'

> *It's an airy, white-walled room, more like a hangar or an exhibition space (in fact, it's a converted paddle tennis court), with a mezzanine gallery and large skylights.*

Even now, he still paints for half a dozen hours a day. For his 2016 Royal Academy exhibition *82 Portraits and 1 Still-life* Hockney allotted three days to each sitter, spending about 20 hours on each portrait, working fast on day one, and much slower on the third day, adding a few marks and touches.

His Hollywood Hills studio in Los Angeles is rather different from the rural villages of East Yorkshire. It's an airy, white-walled room, more like a hangar or an exhibition space (in fact, it's a converted paddle tennis court), with a mezzanine gallery and large skylights. It's quite neat, full of canvases and a trolley full of brushes, but sparsely furnished apart from a comfortable armchair. Known throughout his life for his extravagantly coloured clothes, spectacles and suits (for many years bought from Savile Row tailors Fallan & Harvey), here he tends to work either in suits or in cardigans and paint-splashed trousers.

Hockney usually paints in silence, a Camel Wides cigarette never far from his side.

Katsushika Hokusai
Two brushes and four chopsticks

Various studios, Edo, Japan

Hokusai pared down his studio equipment to the basics.

Painter and printmaker Katsushika Hokusai (1760–1849) was the leading light of the later Japanese *ukiyo-e* (literally 'pictures of the floating world') tradition, focusing increasingly on landscape and the natural world. His most famous work is *The Great Wave off Kanagawa* (1831) that is part of the woodblock series *Thirty-Six Views of Mount Fuji*. Among his many devotees was Vincent van Gogh (see page 172) whose collection of Japanese prints almost certainly included some of Hokusai's.

Over his lifetime it is estimated he produced approximately 30,000 various works of art, paintings, sketches, woodblock prints and picture books. In the introduction to his series of illustrated books *One Hundred Views of Mount Fuji* he wrote that he developed his artistic passion aged six, but that everything he drew until he was 70 was forgettable, and that he only started to partially understand the structure of flora and fauna from then on. He added that by the age of 100 he would reach 'the level of the marvellous and divine'.

> *Over his lifetime it is estimated he produced approximately 30,000 various works of art, paintings, sketches, woodblock prints and picture books.*

Hokusai was a great sketcher throughout his life from his days as a young child. In his late eighties, he spent a year swiftly making a daily drawing of a 'lion dancer' from the traditional Japanese and Chinese dance. He called this his *Nisshin-Joma* or 'Daily Exorcism', partly using it to put himself in an artistic frame of mind, but also as a charm or personal prayer to give thanks for a long life largely free of adversity before getting down to the real work of the day. Many of these sketches he simply threw away, but happily a good collection still survives.

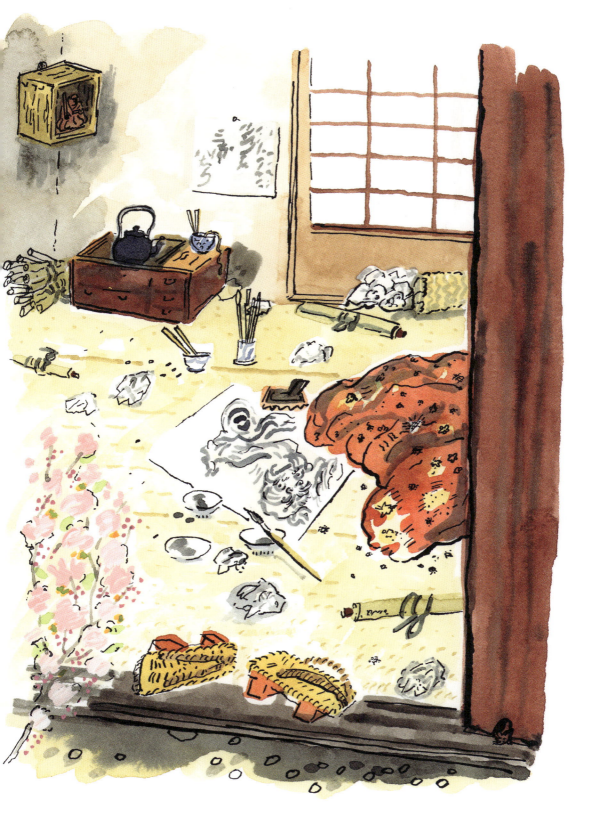

Most of what little information we know about his working environment in the 1840s is thanks to a roughly contemporary drawing by his student Tsuyuki Kōshō. This depicts a crouching Hokusai at work on the floor, a brush in his hand and covered by a thick quilt, surrounded by empty food wrappers, charcoal to keep the room warm, and with a tangerine box used as a shrine to the thirteenth-century Buddhist evangelist Nichiren. Nearby, a long pipe in her hand, is his daughter Katsushika Ōi, herself an acclaimed artist, who some believe may have produced some of the later work attributed to her father. The image also includes some text by the master's apprentice describing how Hokusai would essentially crawl into his quilt in autumn and stay in it while he worked until the following spring, lying down to sleep when tired, picking up a brush and painting as soon as he woke up. As a result, the quilt became infested with lice.

This was his working pattern throughout his career. Rather than clean up, he simply moved house — more than 90 times in total — partly to avoid visitors who might disturb him as he worked from home but mostly to avoid the washing up. The story goes that a visitor to his house who had come to commission a painting made the mistake of commenting that there was nowhere hygienic to sit down. Rather than apologize, the artist berated him for being rude and demanded an apology.

Hokusai's studio was wiped out in an 1839 fire that also destroyed much of his work. Legend suggests that the only things he snapped up as he escaped the flames were his brushes so that he could keep working elsewhere. His work certainly came before everything else so that, even though hugely successful, in his later years he remained living very frugally with little or no furniture and only the minimum amount of crockery (teapot and cups). In the 2015 Japanese anime film *Miss Hokusai*, which focuses on this strange working lifestyle of daughter and father, Ōi remarks that they can deal with whatever life throws at them since all they need are 'two brushes and four chopsticks'.

Tove Jansson
Building the ideal studio

Ullanlinnankatu, Helsinki, Finland

Jansson's studio: not many Moomins.

Creator of the Moomins Tove Jansson (1914–2001) was delighted to move away from her family home in Helsinki towards the end of the Second World War to enjoy independence in her own studio, what she described as a 'turret', in the city centre on Ullanlinnankatu. It was cold — initially she painted wearing a hat, coat and scarf — and slightly knocked about by bombs. The roof leaked, the radiators stopped working, the wind gusted through broken windows and down the chimney. Mounds of rubble lay against cracks in the wall. Still, she said: 'The first time I came into the new studio ... I just stood and looked, and was happy.'

Initially Jansson only rented the space and came close to losing it several times to the owners who wanted to develop it. These caused her worries about where else she could find with enough room for her worktable, canvases, sculptures and huge bookshelves. But once the *Evening News* in London signed her up for a regular Moomins strip she became sufficiently financially secure to buy it outright and turn it into a comfortable working environment; one where she finished *The Moomins and the Great Flood* in 1945, the first in the Moomins series (the text always came first in each book, followed by the illustrations).

'Twelve windows reaching out to the light and as high as a church' is how she described the tall-windowed and 6m- (20ft) high ceiling space, split over two levels with an L-shaped mezzanine. The studio took up most of the space with a small bedroom behind and a toilet decorated with a collage of magazine pictures of disasters, including an erupting volcano and ships battling squally seas. There was no kitchen but there were plenty of full bookshelves with a range of art books and works by Maupassant, Zola and Vasari. There was also room for her father Viktor's sculptures, including many of herself as a girl.

The walls were decorated with her own paintings and posters by French painter Théophile Steinlen. Interestingly, there is little evidence of the Moomins in the studio, preserved as she left it when she died but not currently open to the public.

The flat's design, including the steep wooden staircase to the mezzanine, was a joint effort between Jansson, her life partner artist Tuulikki Pietilä, and Pietilä's architect brother. Among Jansson's personal touches were the removal of the jambs in the windows — the tallest of which offered her a view of the sea and her childhood school — to lessen problems of shadowing on sunny days. 'I've tried to build a home, an ideal studio in the turret I've been dreaming of all my life,' she said. 'A studio one could spend one's whole life beautifying if one wanted to.'

> *The flat's design, including the steep wooden staircase to the mezzanine, was a joint effort between Jansson, her life partner, artist Tuulikki Pietilä, and Pietilä's architect brother.*

As well as working in the studio, Jansson entertained visitors here. Among them was long-standing friend, the photographer Eva Konikoff, who took a series of photos of the studio that Jansson loved ('They're the most authentic pictures to have been taken here, both of me and of the studio,' she told Konikoff). In a 1944 letter to her, Jansson described her studio as 'magnificent ... with six arched windows and above them little rectangular windows like eyebrows on top under the ceiling.' She admitted that the bomb-damage repairs were still unfinished, and so her easel was set up in the middle of the debris. She also talks about the studio's 'colossal, ornate Art Nouveau stove'.

Pietilä's studio was nearby on the same floor, separate but connected via a narrow passageway. In her novel *Fair Play* (1989), Jansson fictionalizes their relationship in the story of a couple who live and work in adjoining studios. Jansson's other working studio was the simple single-room cabin that she built with Pietilä on the remote island of Klovharun off the Finnish coast. Here they worked together from April/May to September. Although the cottage was small, they had their own desks and workspace.

Frida Kahlo
From hospital bed to Blue House

Casa Azul, Coyoacán, Mexico

Kahlo's studios were as unorthodox as her art.

The life of Mexican painter Magdalena Carmen Frida Kahlo y Calderon (1907–54) was dramatically changed in 1935 when, aged 18, she was badly injured in a bus accident that left her needing medical treatment for the rest of her life. While recovering in hospital initially and then in bed at home, she began to paint to pass the time using her father's oil paints and brushes, and with an easel specially set up by her bedside so she could paint while lying down. Her mother Matilda set up a large mirror above her in the canopy of her bed, giving her plenty of opportunity for self-contemplation and self-portraits. 'I paint myself because I spend a lot of time alone and because I am the subject that I know best,' she said.

'I paint myself because I spend a lot of time alone and because I am the subject that I know best,'

Three years after the accident, Kahlo began a relationship with the Mexican fresco specialist Diego Rivera, 21 years older than her, whom she married the following year. The couple had a volatile marriage. Both had affairs, yet they still lived together in a remarkable complex of twin houses connected by an elevated bridge, all designed by painter and architect Juan O'Gorman, a friend of Rivera's, and now open to the public. Diego had the left house, and his double-height studio remains full of the papier-mâché sculptures of humans and animals that he was fond of producing. Frida had the right one with a studio on the second floor. On her father's death she moved back to the Coyoacán house where she grew up, Casa Azul (the Blue House), since 1958 a popular house-museum.

Her bedroom and studio are on the upper floor. As well as much of the original furniture, Frida's ashes are on display in a frog-shaped urn in her bedroom, in addition to the plaster

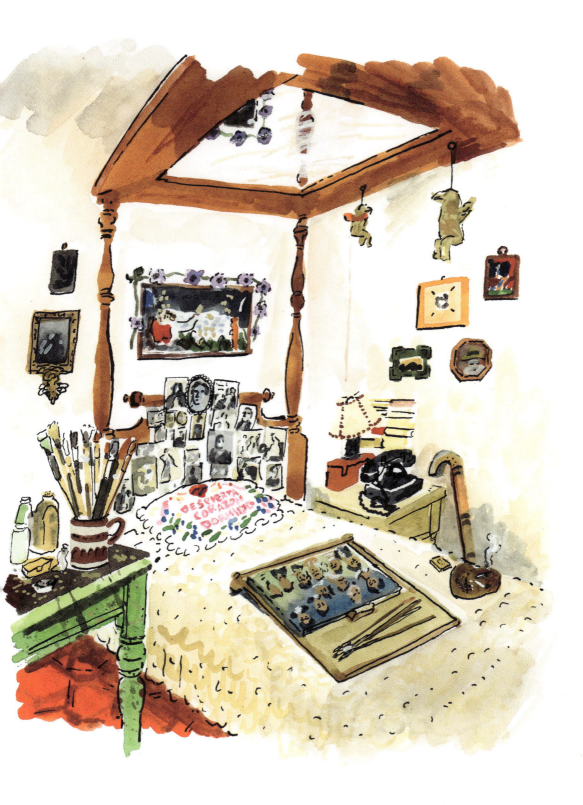

corset she wore to support her spine and that she painted and decorated herself.

In her studio her wheelchair is left in place in front of the easel where she worked (reputedly given to her by businessman and politician Nelson Rockefeller) in front of an unfinished painting as if she had just left the room for a moment. This is the room in which she produced some of her most famous work including *The Two Fridas* (1939) and *Self Portrait with Thorn Necklace and Hummingbird* (1940). Large windows giving out to the gardens make this a very light-filled space.

There is also an intriguing selection of books over several shelves, with guides to flora and fauna rubbing shoulders with the works of Lenin and Marx, Walt Whitman's and Lord Byron's poetry, Montaigne's essays and Pancho Villa's memoirs, as well as a wide selection of art books stretching from prehistoric works to New York cartoonist Peter Arno, and a selection of essays, including one on Rivera. Nearby is a series of wooden boxes painted

white by Frida who then added collage decoration before filing important material away in them such as letters from Rivera (this decorated with a card from the Mexican card game Lotería featuring a heart with a knife in it).

Over the years, Kahlo's working routine varied considerably. When she lived with Rivera, she tended to get up late and not start work until after lunch. In 1943 she began teaching at a new art school in Mexico City, the Esmerelda, where her unorthodox methods were loosely inspirational rather than directly didactic, encouraging pupils to get out of the classroom and paint what life was like in the city's streets. In a letter to her educator friends Ella and Bertram Wolfe in 1944, she explains that her schedule for teaching days usually ran:

8am — start
11am — finish
12 noon — return home and eat, clean, tidy up, have a quick wash
2pm — work ('I have my afternoon free to spend on the beautiful art of painting' she wrote)
Evening — go to the cinema or theatre

She then returned home and usually slept soundly.

Angelica Kauffman
A salon to celebrate

72 Via Sistina, Rome, Italy

Kauffman's studio-salon was a must for Grand Tourists.

Born in Switzerland, Angelica Kauffman (1741—1807) may have made her name in London, but it was her studio and salon in Rome that elevated her to the heights of eighteenth-century artistic superstardom.

Known for her history paintings and as a celebrity portraitist, Kauffman was a founding member of the Royal Academy of Arts in London in 1768, along with Mary Moser (the next woman was Annie Swynnerton in 1922, followed by Laura Knight, see page 100, in 1936). In 1766 she set up her first studio in Suffolk Street, Charing Cross (at the home of a surgeon and his family), and the following year moved to 16 Golden Square in Soho, a more fashionable address with northern light that was built in the 1680s and demolished in 1908.

In each, she had a space to paint, plus a separate one where she could exhibit her works to potential buyers. This was the fashion of the time — her friend the painter Joshua Reynolds had exactly this set-up around the corner in Leicester Square — and it was important to Kauffman to maintain an elegant and impressive home and working space that was also decorous. 'The most refined ladies come to the house to sit — to visit me — or to see my work,' she wrote to her father, emphasizing the propriety of her working conditions. 'I could not receive people of such high rank in an ill appointed house.' Kauffman was certainly in demand in London. So great were the numbers of aristocratic visitors to her studios that nearby streets were often blocked by carriages belonging to those calling on her. Among these visitors to the studio was Augusta, the dowager princess of Wales and mother of King George III.

She continued to build on this success when she moved to Rome in 1782 with her husband, the Venetian painter Antonio Zucchi. She set up home and studio at number 72 on the Via

Sistina, a popular location for artists and foreign ones in particular, just above the famous Spanish Steps and beside the Trinità dei Monti church. Her 15-room palazzo — the former house of the German painter Anton Mengs — soon became one of the city's major cultural hubs and she was dubbed 'possibly the most cultivated woman in Europe'. Dr Johnson's close friend Hester Thrale stopped in Rome in April 1786 and commented that Kauffman 'though neither English nor Italian, has contrived to charm both nations …Besides her painting for which the world has been the judge, her conversation attracts all people of taste to her house'.

Her 15-room palazzo — the former house of the German painter Anton Mengs — soon became one of the city's major cultural hubs and she was dubbed 'possibly the most cultivated woman in Europe'.

Here, a visit to her and her studio-salon became a stop in itself on the grand tour that many rich young men from across Europe undertook at the time. An inventory taken after her death indicates that her working studio was full of the usual requirements of a busy painter's life: brushes, easels, palettes, equipment for grinding pigments, mannequins, and various plaster and terracotta torsos and heads. There were also sets of steps to enable her to reach high canvases and mirrored lamps to light up her work.

A separate studio was used to store her finished works and those in progress, but so well-known did she become that this was not the same kind of 'shop front' studio she had run in London to attract clients, although the reception rooms in her home were partially decorated with her recent paintings. Among guests were the writer Johann Wolfgang von Goethe and sculptor Antonio Canova. Royalty visited too, including Emperor Joseph II of Austria in January 1784, who spent an hour in her studio.

Interestingly, Kauffman's friend Giovanni Gherardo De Rossi's 1810 biography of Kauffman suggests that her husband looked after the day-to-day domestic running of their home so that she could concentrate on her work.

Laura Knight
A dressing room, a bomber factory and a Rolls Royce

Lamorna, Cornwall, England

Laura Knight: taboo in the studio.

As a young female artist, Dame Laura Knight (1877–1970) was barred from attending life-drawing classes at art school because she was a woman, allowed only to work with plaster casts. Consequently, when her taboo-breaking 1913 *Self Portrait with Nude* (initially simply called *The Model*) subverted this convention, it caused considerable frenzy in the art world. Acclaimed as the first example of a painting showing a female artist at work on a life drawing, it depicts her friend — the model and artist Ella Naper — posing naked, Knight wearing a favourite scarlet cardigan and a very respectable black hat as she works on the study in her studio at Lamorna in Cornwall. Typical of the largely hostile mainstream reaction was the *Daily Telegraph*'s art critic Claude Phillips who called it 'dull' and 'vulgar' adding that it 'might quite appropriately have stayed in the artist's studio'.

Knight's previous studio (now an artists' gallery) had been on the Yorkshire coast in Staithes, shared with her husband and fellow artist Harold. While her time there was useful in developing her technique, it was not an unqualified success and in her autobiography she talks about the warmth given off in her studio by the burning of her canvases and drawings.

With the move to Cornwall, where she became a part of the Newlyn community of artists, she became increasingly keen to work *en plein air*, including beach scenes of people swimming and sunbathing, only using her studio to make the final touches.

After the First World War, she and Harold moved to Langford Place in London, although they kept a studio in Lamorna to which they regularly returned. In the capital they each had their own studio, working harmoniously but separately, hers north-lit with a high ceiling. 'As for my own studio,' she wrote, 'I was lucky if he came there once a year, and latterly most of my work he saw for the first time in exhibitions.'

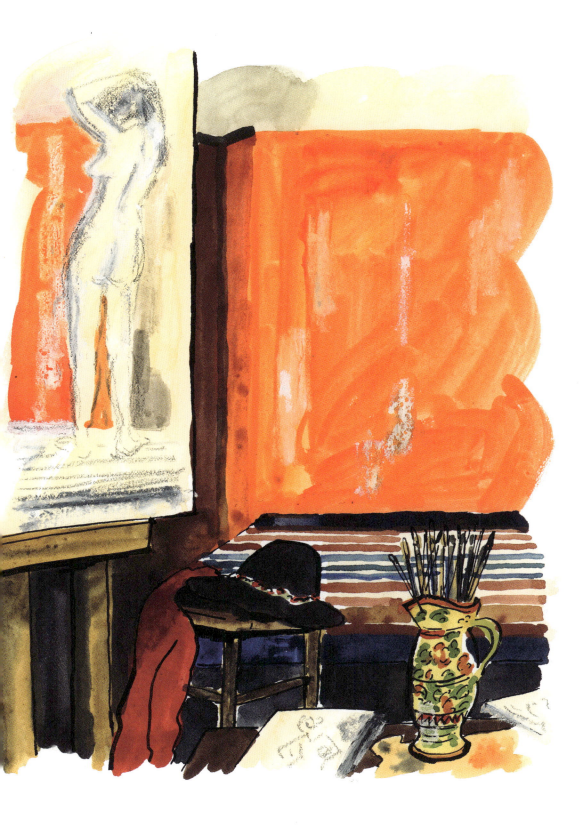

The sitting experience

It often takes two to tango in the studio and for those sitting for portraits it is not always a happy experience. 'This day I begun to sit,' wrote Samuel Pepys in his diary for 17 March 1666, 'and I sit to have it full of shadows, and do almost break my neck looking over my shoulder to make the posture for him to work by.'

The portrait by popular English portraitist John Hayles (c.1600—79) is the one of the famous diarist that is most familiar to us in the twenty-first century. Pepys had additional sittings on 20 March ('I do not fancy that it has the ayre of my face'), the 23rd ('it comes on a very fine picture'), 28th ('it is become mighty like') and 30th ('sat till almost quite darke'). These entries show that his other friends were present and music and singing accompanied part of the process. On 16 May, he wrote that he was 'very well satisfied' with the result.

James McNeill Whistler (1834—1903) was particularly well known for insisting that those sitting made no movement. In 1872—73 he worked on a portrait of historian Thomas Carlyle, the sittings going on much longer than initially agreed. Scottish watercolourist Hugh Cameron who was present for some of them noted: 'It was the funniest thing I ever saw. There was Carlyle sitting motionless, like a Heathen God or Oriental sage, and Whistler hopping about like a sparrow.'

It could be a lot worse though. English painter Sir John Everett Millais (1829—96) insisted that his 19-year-old model Elizabeth Siddal, providing the inspiration for his *Ophelia* (1851), wear a silver-embroidered dress and lie in a bath of water to achieve the desired effect. She caught a rotten cold as a result.

And, of course, not everybody is pleased by the results. 'If I really have as bad an expression as my photograph gives me, how I can have one single friend is surprising,' Charles Darwin wrote to his biologist friend and colleague Sir Joseph Dalton Hooker in May 1855. Darwin was very interested in photography and exchanged regular photo portraits, or *cartes de visites*, with friends. But he did not like all of them. 'For Heaven-sake oblige me and burn that now hanging up in your room,' he wrote to Hooker in December 1860. 'It makes me look atrociously wicked.'

Although she did paint landscapes, Knight spent much of her working life painting theatre, ballet and circus performers, and enjoyed working in makeshift studios, often with an eye on useful media publicity. Photographs show her using a rented Rolls-Royce at the Epsom Derby as an improvised studio, and in the Second World War getting ready to work in a bomber factory on a work bench. She also became friends with Ballets Russes ballerina Lydia Lopokova, who gave her permission to turn her dressing room into a temporary studio. Rather than pose, Lopokova would go through her normal warm-ups and make-up routines naturally while Knight sketched, all without any conversation.

She also appeared in a 1927 British Pathé newsreel at work sketching a model (fully clothed) in a mocked-up studio. 'Tireless and sturdy,' runs one caption, 'Mrs Knight is never so happy as when she is in her beloved studio.'

Knight was elected a full member of the Royal Academy in 1936 (only the third since it was established 200 years previously), more than two decades after it rejected *Self Portrait with Nude* for its 1913 Summer Exhibition. The National Portrait Gallery bought the painting in 1971 and describes it as 'a bravura statement about the ability of women to paint hitherto taboo subjects on a scale and with an intensity that heralds changes'.

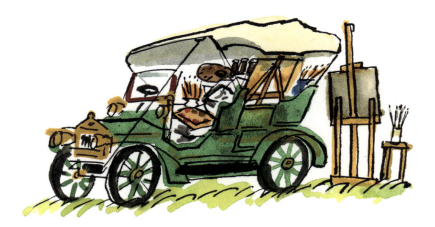

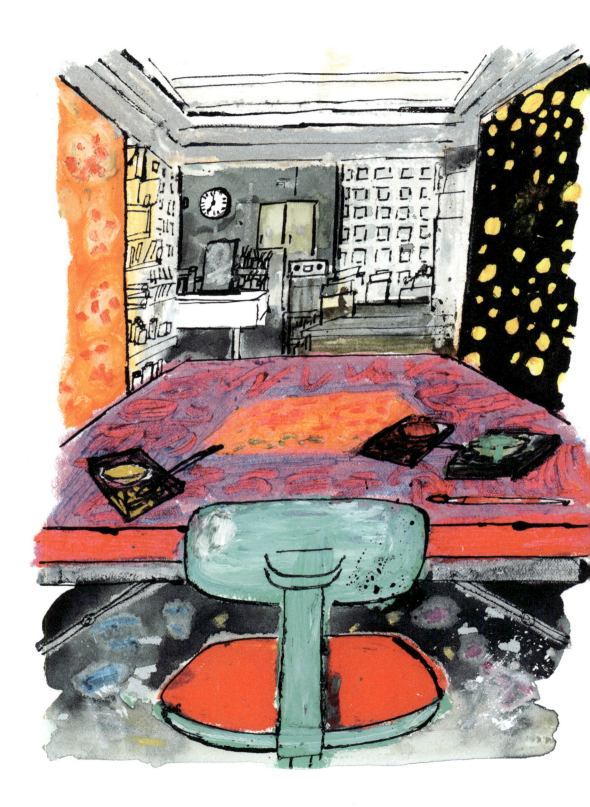

Yayoi Kusama
A place for 'happenings'

Various studios, New York (USA) and Tokyo, Japan

Painter, sculptor and installation artist, known in particular for her brightly coloured polka-dot themes and mirrored spaces, Yayoi Kusama (1929—present) has had a long artistic journey. From her mother actively discouraging her as a young girl in rural Japan from following a career in the art world to becoming one of the top-selling artists on the planet. She is still working in her nineties.

Kusama moved from her homeland to America in 1957, first to Seattle and then to New York where she established a studio. Here she became part of a group of artists rethinking art, and her work influenced peers such as Andy Warhol and Claes Oldenburg. Among her friends and mentors who visited here there were Georgia O'Keeffe (see page 138). Closer friends included Donald Judd, whose studio was in the same four-storey building at 53 East 19th Street. Judd has described her amazing work ethic as 'obsessive', often working through the night and finishing paintings in a single session. Judd also helped her in the studio with her soft sculpture works, including the phallic armchair, *Accumulation No. 1* (1962).

She was certainly much of a force to be reckoned with. Her art encompassed numerous 'happenings' or what Kusama calls 'body festivals' that she held both in her studio and in public locations in the city and for which she painted models' nude bodies. One of these happenings was staged in her studio in 1968 and centred on the reading of an open letter she wrote to President-Elect Richard Nixon calling on him to end the Vietnam War; one of the incentives for doing so was a session with Kusama in which she promised to paint his 'hard, masculine body' with polka dots.

Kusama returned to Tokyo in 1973 when her mental health faltered and, since the late 1970s, she has, by choice, lived in

Kusama's studio is a key part of her therapy.

Seiwa Hospital, a psychiatric institution that has helped her deal with lifelong hallucinations and mental stress. In her autobiography *Infinity Net* (2003), Kusama talks about what she calls her 'fixed schedule' — bed at 9pm, then a 7am blood test on waking up the following morning, then to the studio until about 6pm or 7pm. 'Since moving to Tokyo,' she says, 'I have been extremely prolific.' While this schedule sounds very tiring, she estimates that she worked harder during her years in New York.

Her art encompassed numerous 'happenings' or what Kusama calls 'body festivals' that she held both in her studio and in public locations in the city and for which she painted models' nude bodies.

Although she does have a small working space at the hospital, almost every day she is driven to her nearby studio in an unremarkable three-storey building in Tokyo's Shinjuku district. A small, neat reception area gives on to her main studio where she also maintains an archive of key ephemera of her life, from plane tickets to photographs of her exhibitions. The main room has a modern feel with canvases stacked around the walls. In the centre is a large worktable around which Kusama creates, sat in a chair with castors so that she can easily move around the canvas that lies flat on a table. Although she does have working clothes, she says that a lifetime of work means that all her clothes, including her pyjamas, are stained with paint.

Kusama has vowed to continue painting for as long as she still physically can, taking only a short 30-minute break each day for lunch, since she maintains that art is what keeps her alive, as vital a form of therapy for her as it was for Frida Kahlo (see page 92).

René Magritte
At home in slippers

135 Esseghemstraat, Brussels, Belgium

For an artist synonymous with surrealism, the 'studio' where René Magritte (1898–1967) worked is surprisingly simple. Or, depending on how you look at it, it's startlingly surreal.

Magritte was born in Belgium, then lived in Paris in the 1920s, before moving back home to Brussels in 1930 with his wife Georgette. Here he lived and worked in an unpretentious ground-floor flat at 135 Esseghemstraat for the next 24 productive years. Rather than any kind of grand studio space, Magritte painted in the corner of his dining room, close to his collection of Sèvres porcelain. This meant that at the end of the day, rather like a keen hobby painter who doubles up on space, Magritte cleared everything away to make room for his evening meal. On Sunday evenings it became the setting for regular meetings of the city's group of surrealists.

Foregoing anything as traditional as artist's overalls, in this cosy atmosphere he painted in his suit and tie, wearing his slippers. Georgette often sat with him as he worked.

Magritte played with using everyday domestic objects in incongruous settings or pairings. Since he worked from home, this means that his inspiration was often not too far away. His staircase and internal doors appear in several works, while the fireplace from which the steam train emerges in his 1938 *La Durée poignardée* (Time Transfixed) is clearly his own. 'I decided to paint the image of a locomotive … in order for its mystery to be evoked, another *immediately* familiar image without mystery — the image of a dining room fireplace — was joined,' he said. Art

Magritte's straightforward studio: *Ceci n'est pas un atelier?*

commentators also connect the skies in his paintings to his view from the flat.

Sotheby's 1987 auction called *The Remaining Contents of the Studio of René Magritte* also gives us a peek into what it contained. Lot 925 (sold eventually for £41,800 to Linda McCartney who gave much of it as a birthday present to her husband Paul) consisted of:

- An oak easel *c.*1930 with sliding canvas grips to each side and some blue paint, the whole raised on scroll feet.
- Three stained wood paintboxes containing assorted used tubes of oil and gouache, seven brushes, a palette knife, scrap paper, a tads hammer, a ruler and a pair of paint-splattered tortoiseshell spectacles (McCartney reported they were 'a very powerful prescription').
- An oak worktable (twentieth century) containing two drawers with contents including pliers, nails, rulers, a palette knife and other tools for stretching and mounting.
- Artist's materials in an embossed green leather case, including 12 paint brushes in assorted sizes, pens, Caran d'Ache crayons, tubes of used oil paint, three blank cavasses, paper, varnish, oil and an artist's palette with oil paint marks.

Lot 926 was a black bowler hat, initialled on the interior R.M. with a simple black ribbon trim, and probably used for posing for photographers since he rarely wore one. It sold for £16,500.

Magritte had a more conventional studio at the bottom of the garden built in 1933, a freestanding garden office almost entirely glass-pannelled at the front, from which he operated an advertising agency called Studio Dongo with his brother Paul. Here, he worked as a more conventional commercial graphic artist for a range of companies, including Alfa Romeo and Belgium's former national airline Sabena.

The five-floored house is now wholly the René Magritte Museum after it was bought by art collector André Garitte in 1993 and opened to the public five years later.

Michelangelo
Noisy places full of dust and debris

Castel Sant'Angelo, Rome, Italy

Michelangelo: dirty, dusty studios. And as for his trousers ...

The concept of a studio has changed dramatically over the centuries. What we now think of as a typical example didn't really exist among the leading artists of the sixteenth century. Instead, they ran workshops or *bottega* that were more along the lines of Andy Warhol's Factory (see page 180) or Damien Hirst's operation, with plenty of assistants and apprentices learning the ropes from more experienced artists. Workshops in Florence around the time when Michelangelo (1475–1564) was apprenticed in Domenico Ghirlandaio's workshop were also usually open to the street, partly because of the access to light, partly because they also acted as shop windows for buyers.

This was not how Michelangelo worked and indeed art critic James Hall calls him 'anti-studio'. An anecdote from the groundbreaking mid-sixteenth century book *The Lives of the Most Excellent Painters, Sculptors, and Architects* (1550) by Giorgio Vasari recounts how Michelangelo visited a sculptor who was fussing about how a finished work should be lit in his studio. Michelangelo told him not to bother, that 'the important thing will be the light of the Piazza' where it was to be displayed.

Rather than build up a traditional workshop structure he preferred to work alone, although he certainly had assistants to help with painting the ceiling of the Sistine Chapel in the Vatican (1508–12). And not everybody was denied access — according to Vasari, Pope Julius II arranged for a drawbridge to be built to connect the Vatican to Michelangelo's studio in Castel Sant'Angelo so he could nip across and watch him at work.

He did, of course, have structures. A plan of around 1545 by Michelangelo of his residence in Florence indicates that he had some kind of a workshop at the front of the building and a small *studiolo* or study at the back where he would work on more speculative ideas, modelling and planning.

It's hard to know exactly what his workspace surroundings were like, but, as for any other artist of the time working in stone, they were bound to be noisy places, full of dust and debris. Michelangelo's frequent dissection of corpses to learn about anatomy added another layer of filth. On top of which Michelangelo's earliest contemporary biographers — including Vasari and historian Paolo Giovio around 1527 — report that he tended towards the messy side of dressing and living in general, rather than splurging on fine clothes; quite a contrast to his contemporary Leonardo da Vinci (see page 54). Vasari mentions that Michelangelo wore special leggings made of dog-skin leather to protect his legs against the damp, but sometimes kept them on for months at a time so that often his skin came away when he took them off.

Michelangelo had workshops in the Macello de' Corvi (which Pope Paul III visited to urge Michelangelo to complete the *Last Judgement* on the altar wall of the Sistine Chapel) and the Via Mozza, which was broken into — probably by a rival — and

various chisels, drawings and models stolen. He worked on perhaps his best-known work, *David* (1501–04), behind scaffolding in the workshop of Florence's cathedral and later inside a wooden shed (to which he naturally admitted nobody else).

Another place that Michelangelo used as a kind of studio was discovered in 1975 and opened to the public on a limited basis in November 2023. This was an underground space in Florence's Basilica di San Lorenzo where he is believed to have hidden for a while during a time of political turbulence. The walls here are covered with drawings believed to be the work of Michelangelo and his assistants.

Mentors and protégés

'Take it, feel it and pass it on' says Hector to his school pupils in Alan Bennett's play *The History Boys* (2004) about the baton of knowledge. Leonardo da Vinci (see page 54) added his own artistic twist, arguing that it is a poor student who fails to outshine his master.

It's also possible to build up a kind of 'family tree' of these relationships. So Italian painter Domenico Ghirlandaio (1448–94) took on his teenage countryman Michelangelo as an apprentice. He in turn took under his wing Cremona-born Sofonisba Anguissola (*c.*1532–1625), described by art historian Giorgio Vasari as exhibiting 'greater application and better grace than any other woman of our age', and who became an official court painter at the Spanish court of Philip II. Towards the end of her long life, she was visited at her home in Palermo in 1624 by the Flemish painter Anthony van Dyck (1599–1641) who made a sketch of her.

'As I was making her portrait, he notes alongside the sketch, 'she gave me many hints, such as not to take the light from too high in case the shadows in the wrinkles of old age should become too strong, and many other good sayings, as she went on telling me parts of her life, by which I knew that she was a painter by nature and wonderful, and the greatest trouble she had was that from lack of sight she could paint no more, though her hand was firm without tremor of any sort.'

His portrait of the remarkable nonagenarian is part of the National Trust's collection at Knole in Kent.

Joan Miró
A studio to fit the landscape

Palma, Mallorca, Spain

Joan Miró's bespoke studio features a balcony.

'I dream of a big studio,' wrote Joan Miró (1893–1983) in 1938 in an article for the French journal *XXe Siècle*. He recalls arriving in Paris in 1919 and working in a studio at 45 rue Blomet where the windowpanes of his studio were broken, his heater wouldn't work and he could only afford one lunch a week (eating dried figs and chewing gum for the others). Even when he returned on regular trips to the country of his birth, Spain, he wrote that he never had a proper studio. His dream was to settle down in a 'very large studio' simply to have more room for his canvases, sculptures and printing press.

In 1956 he moved to Mallorca and asked leading architect Josep Lluís Sert to build him a studio, one that blended into the island's rural landscape. He also wanted the areas where he worked and where he stored his work quite separate, so that he couldn't see largely completed work while he was at work on something new. Sert was in exile in the USA following Franco's rise to power. This meant they exchanged ideas about the importance of insulation, ventilation and the roof line, as well as a scale model, by mail.

Sert came up with an L-shaped studio built of concrete, over two levels, with a vaulted ceiling and wing-like roof; one whole wall was made up of blocks of stone to give the impression of a cave. Miró decorated the interior of his studio with his collection of miscellaneous items: postcards, clippings, stones, shells, local clay whistles, nativity crib figures, Oceanic masks and Hopi Native American *kachina* dolls. Not to mention the mummified cat that had accidentally been shut into the studio while Miró was on tour for several months … He picked up much of this collection of folk art and found objects on his regular long walks around the island, and found it artistically inspirational and personally comforting.

Today, in the Foundation that cares for the studio, these items still sit beside his canvases, brushes and paints, and his paint splatters on the tiled floor. Although it faces out towards the sea, what it doesn't have is any kind of view, light mostly coming in from huge skylights overhead. The bright white façade with colourful colour blocks on doors and shutter panels has a Mondrian quality to it. Sert used mostly local and natural materials for stonework, tiles and the studio's cabinets and furniture. 'I think you'll like it,' he wrote to Miró, 'it's the kind of building that will fit in with the landscape.'

> *Although it faces out towards the sea, what it doesn't have is any kind of view, light mostly coming in from huge skylights overhead.*

The size of the studio meant Miró could work on canvases placed on the floor as well as on easels and Sert also included a mezzanine. 'Being able to see the entire studio space and the canvases from the balcony strikes me as an excellent idea,' a delighted Miró wrote to him. When it was completed in 1957, Miró was thrilled with the result, telling Sert that it was 'magnificent, truly impressive'. In fact, he found it initially quite overwhelming and suffered a kind of artist's block, requiring time to get used to working in this ideal space.

Miró's daily routine would be to wake up early, around 6–7am, and head to the studio after a light breakfast. Before work, he read poetry or listened to music, but then worked in silence and alone. His wife Pilar tidied up when he left the studio, but cautiously, as he was particular about keeping his tools in exactly the same position. He would work until noon, then stop for exercise. Throughout his life he kept in shape by swimming, running, boxing and skipping. After a brief siesta and time answering letters, he would work again in the studio until dinner.

Several years after Studio Sert was finished, Miró bought a nearby eighteenth-century house, Son Boter, in which he added further studio space for engraving and lithography, as well as his own graffiti on the walls.

'Poetry surrounds us, but putting it on paper is not so easy.'

Vincent van Gogh

'As the sun colours flowers, so does art colour life.'

John Lubbock

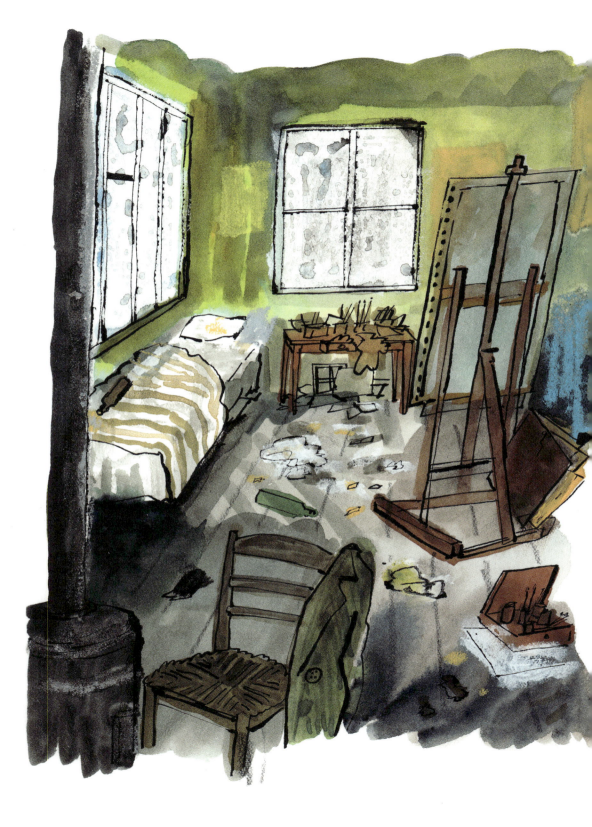

Amedeo Modigliani
Stone heads for candlesticks

Various studios, Paris, France

Modigliani: vying with Francis Bacon for messiest studio.

Italian painter and sculptor Amedeo Modigliani (1884–1920) spent most of his working life in Paris. Initially very tidy and smart when he arrived in the capital in 1906, he quickly became messy in his work and dress, developing a hard-drinking, promiscuous bohemian lifestyle. He worked fast and erratically, usually while smoking and drinking, sometimes completing works in virtually a single session, sometimes chopping and changing almost endlessly, almost always charging a trifling fee. His constant lack of money was one of the reasons for his constant changing of studios, one of which he shared with Brâncusi (see page 32).

One of his early studios was on the ground floor at 216 Boulevard Raspail. In her 1932 book of reminiscences of that time, *Laughing Torso* (1932), artist Nina Hamnett describes it as having a glass roof and wall with a garden in which, she says, a watch was nailed onto a tree for him to see the time. She also reveals that sometimes he would come home from nights out at 2am or 3am and start some stone carving. Russian sculptor Ossip Zadkine also remembered visiting Modigliani at his studio and finding him asleep/passed out, naked, with drawings and photographs pinned up on the walls all around him floating in the breeze — he likened it to watching a drowned man being rocked by the waves of the sea.

… visiting Modigliani at his studio and finding him asleep/passed out, naked, with drawings and photographs pinned up on the walls all around him floating in the breeze.

In another of Modigliani's former studios, Hamnett writes that on the end of his unmade bed there was a huge spider's web complete with huge spider. Modigliani apparently had come to

like the arachnid so much he didn't want to disturb it. On this bed she noted, too, copies of *Les Liaisons Dangereuses* (1782) and *Les Chants de Maldoror* (1868). The latter was one of Modigliani's favourite books, an 1869 surrealist prose poem by Isidore Ducasse about evil and immorality, later illustrated by Salvador Dalí.

Modigliani shared his final studio and home at 8 rue de la Grande Chaumière with his partner, Jeanne Hébuterne. Initially, this marked a distinct upturn in his fortunes. His close friend Lunia Czechowska, whom he frequently sketched and painted, remarked that, despite being just two smallish rooms, when he moved in 'his joy was such that we were all deeply moved'. She and Hanka Zborowska, the wife of his art dealer, in fact cleaned and fitted out the studio for him in 1919, painting the windows with *blanc d'espagne*, a kind of cheap chalky whitewash, when their money ran out rather than buying curtains. Hamnett said the walls were painted with different slabs of colour that Modigliani used as backgrounds for his portraits.

Among the slightly alarming features of the studio were a butcher's hook on which he spiked drawings he no longer wanted, and a series of carved stone heads that he failed to sell and consequently used as vast candlesticks. Sadly, the studio was also somewhat damp and, combined with his growing alcoholism and general unhealthy lifestyle — he ate sporadically and left empty tins of food around the apartment — Modigliani died within a year of moving in. A distraught and pregnant Hébuterne took her own life the day after his death.

Tate Modern made a virtual reality replica of Modigliani's last studio in Paris for its major 2017–18 exhibition of his work, including more than 60 carefully researched objects such as cigarette packets, sardine cans, an easel, a bottle of rum and the exact way the windows opened to allow light in.

Piet Mondrian
A geometrically impeccable room

26 rue du Départ, Paris, France

Piet Mondrian: studio as painting.

Dutch painter Piet Mondrian's (1872—1944) studios had quite an impact on visitors. He was a great philosopher of art, and had high aspirations for its potential in the search for truth. His studios in New York, London, Paris and Amsterdam were his laboratories, abstract spaces he created through his paintings, embodiments of his theories of neoplasticism. 'Art,' he said, 'is higher than reality.'

He painted the floor of his studio in Amsterdam black and the walls and furniture white; but it was his next studio, at 26 rue du Départ in the Montparnasse district of Paris, that was the most groundbreaking. It was here, in this irregularly hexagonal space, that for the first time he began displaying his works of geometric lines and brightly coloured (and sometimes blank) cardboard rectangles, which he constantly pinned and re-pinned to walls as he tried to search for a universal spiritual aesthetic. He also painted his stove and record player to fit in with the scheme and advised flipping representational paintings to face the wall so they would become instead simple rectangles. 'A geometrically impeccable room' is how Dutch journalist W.F.A. Röell described it in 1926.

He worked horizontally on a table rather than vertically on an easel, which was only used for display purposes or as an architectural prop for his interior décor vision. In his rue du Départ studio, his table was placed in front of a large window that faced the street. In addition to the usual set of painter's tools, Mondrian also had a large steel bar to help him with his lines, only discovering black and coloured tapes later when he moved to New York. 'The studio is also part of my painting' he wrote to his friend, the British artist Winifred Nicholson, and was sad to be forced out of the Parisian space when the Montparnasse railway station was expanded.

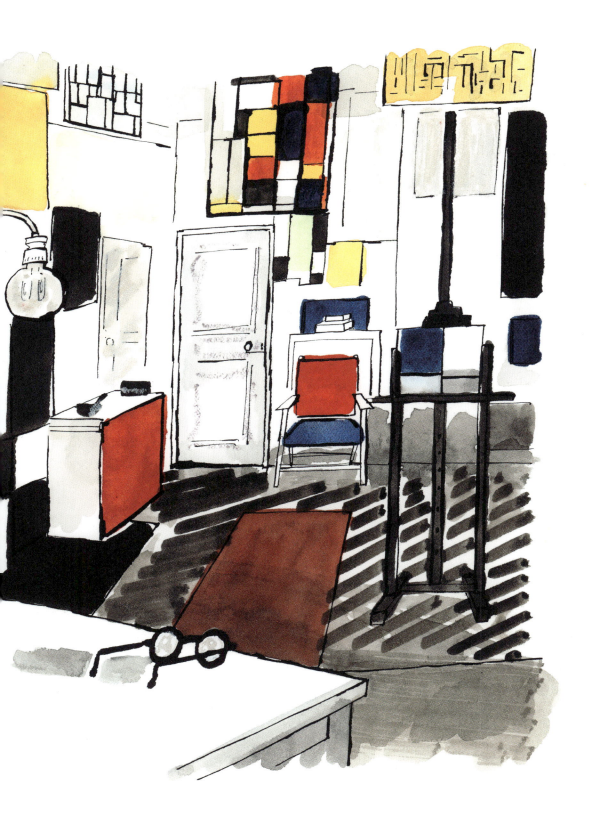

Claude Monet
A floating workspace

Argenteuil, near Paris, France

Monet found that painting on a boat is not all plain sailing.

French painter Claude Monet (1840–1926) had numerous studios, including an absolute whopper that he built at Giverny for his water lily work that he later felt was rather unsightly. By some distance, the most charming was his floating studio boat.

Monet was not the first to work on water. J.M.W. Turner painted various oils on both small wooden boards and canvas while boating on the River Thames during trips in 1805 and 1806. Later in the century, Charles-François Daubigny, whose work influenced the early Impressionists, worked from an 8m- (26ft-) long ferry boat, and he probably recommended the concept to Monet.

It certainly fitted Monet's aspiration of working outside *en plein air*. Bought in 1872 following a successful sale of his work, Monet used the pale green fishing boat during his years living in Argenteuil, a few miles north-west of Paris. He had a partly enclosed wooden cabin built on it and the boat gave him access to otherwise inaccessible vantage points. It also afforded him the chance to experiment with how reflections and light played on water well before he embarked on his *Water Lilies* series at Giverny at the turn of the century.

The boat was fully equipped with necessary supplies so he could spend the day painting on the water, whether on the move or anchored, though these were short trips rather than major excursions. *Régates à Argenteuil* (The Regatta, 1872), one of his most famous works and now in the Musée d'Orsay, was painted from this studio boat.

Monet also included the boat in a number of his paintings, either drifting down the River Seine or moored. His *Le Bateau-atelier* (The Studio Boat, 1876) provides a view of it on the river from the back, looking a little like a small shepherd's hut on top of a rowing boat, its twin back doors opened. A blurred

figure sits quietly inside, either Monet himself or perhaps his wife Camille reading. It's a beautifully peaceful view, with the riverbanks framing the craft reflected in the water below.

His friend Édouard Manet also made a charming study of it in his colourful 1874 *Claude Monet peignant dans son atelier* (Claude Monet in Argenteuil), which shows his behatted compatriot at

Mobile studios

Mobile studios like Georgia O'Keeffe's repurposed car (see page 138) and Claude Monet's boat offered flexibility and the chance to explore otherwise unreachable positions. Among other artists who made use of them was American Impressionist painter Alson Clark (1876–1949) who added a built-in easel and large umbrella (to keep the sunlight at bay) to his truck in order to tour California.

Similarly, but in rather chillier conditions, Scottish landscape painter Joseph Farquharson (1846–1935) used a mobile studio as he captured his trademark snowy scenes with sheep around his family property, the Finzean Estate in Aberdeenshire. The hut also contained a stove to provide comfort on particularly cold days, not least for the servant Farquharson often co-opted to model as a shepherd on location.

More dangerously, English photographer Roger Fenton (1819–69) refitted a former wine merchant's horse-drawn van from Canterbury to provide him with both a studio dark room — it had yellow glass windows with shutters — full of essential chemicals, tripods and glass plates, as well as living and sleeping accommodation. He then used it tour the Crimean War battlefields.

He had more than technical concerns during his time on location. Enemy Russian forces frequently fired on his van, scoring at least one direct hit that tore off part of its roof. When not under fire, Fenton was regularly pestered by officers while he was working inside, who asked him to take their photos so they could send them back home to their families.

'My hut seems to be the rendezvous of all the colonels and captains in the army,' he wrote in a letter from 4 April 1855, 'everybody drops in every day and I can scarcely get time to work for questions nor eat for work.'

It was also very hot inside Fenton's van, and he almost died from inhaling fumes from his chemicals.

work with brushes and portable easel, Camille looking on from under the awning at the front of the boat. Others invited on board included his friend Pierre-Auguste Renoir, the sculptor Auguste Rodin (see page 158) and American artist John Singer Sargent. Sargent's oil *Claude Monet in his Bateau-Atelier* from around 1887 shows Monet at work, suggesting that Sargent is also aboard. Indeed Sargent also used rivercraft as makeshift studios, sketching Venice from the comfort of a gondola.

Of course, painting on a boat wasn't all plain sailing. Daubigny fell overboard once and was almost capsized by a passing boat. American artist Lilla Cabot Perry, reminiscing in The *American Magazine of Art* in 1927, writes about Monet becoming so upset with the progress of one painting while aboard his boat that he threw his paints, palette and brushes into the river.

Monet eventually gave the boat to his friend and fellow artist Abel Lauvray (sadly it has not survived), but that didn't stop him from continuing with his unusual watery painting trips. An account in the French regional newspaper *Le Phare de la Loire*, from 6 November 1886, includes a description of Breton fishermen being surprised to find Monet dressed just like them, painting away on an easel tied to rocks at the coast in the middle of a storm.

Giorgio Morandi
Making a metaphysician's studio: Part II

Bologna and Grizzana, Italy

Morandi's studio was towards the monastic cell end of the spectrum.

Like his contemporary Giorgio de Chirico (see page 56), Italian painter Giorgio Morandi (1890–1964) explored a metaphysical approach to painting, but the results were quite different. 'I believe that there is nothing more surreal and more abstract than reality,' he said. His obsession with the everyday was reflected in the workspace in his Bologna home. His simple studio, in the second-floor apartment in Via Fondazza that he shared with his three sisters, also doubled as his bedroom. This was sparsely furnished but filled with objects he used as props — bottles, vases, cans, bowls, coffee pots and containers filled with coloured pigments, as well as Ovaltine tins painted white.

These were placed, and constantly adjusted after long consideration, on three tables of varying heights and with different backgrounds depending on the effect he wanted to achieve. He used many of the same objects repeatedly, though in different positions to vary the relationships between them. His landscapes often took the view from his studio window as their subject, which was frequently covered to soften incoming light.

Though not a recluse, his nickname was *Il Monaco*: 'the monk'. He told a friend his only ambition was to enjoy the peace and quiet needed to paint. While a cleaner was employed to keep the room tidy, she had strict instructions not to touch any working materials. Morandi was so fond of his routine that it was only when the city was bombed during the Second World War that he reluctantly moved to the countryside.

His other significant studio was at the summer residence he built in the 1950s in the mountain village of Grizzana, south-west of Bologna. Here, too, he accumulated a collection of bottles and containers. His working life overflowed again into his bedroom, tubes of paint and brushes finding their way into his chest of drawers.

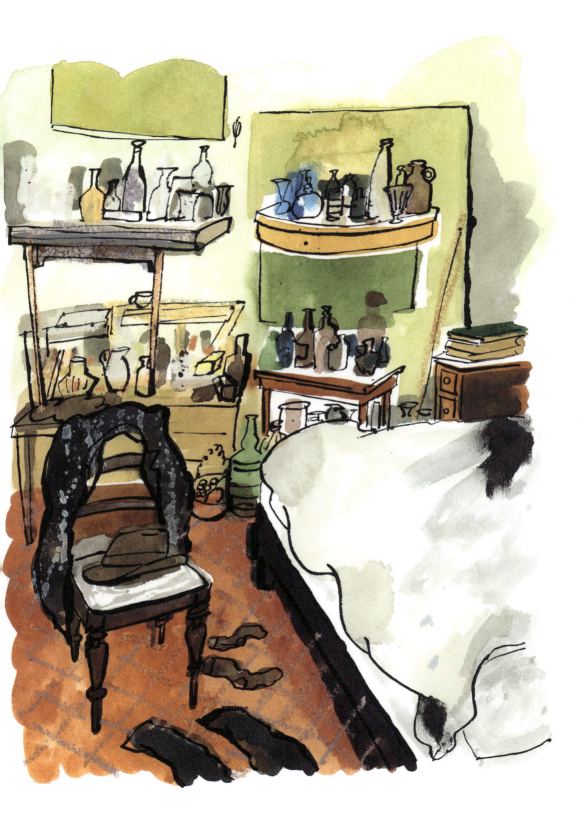

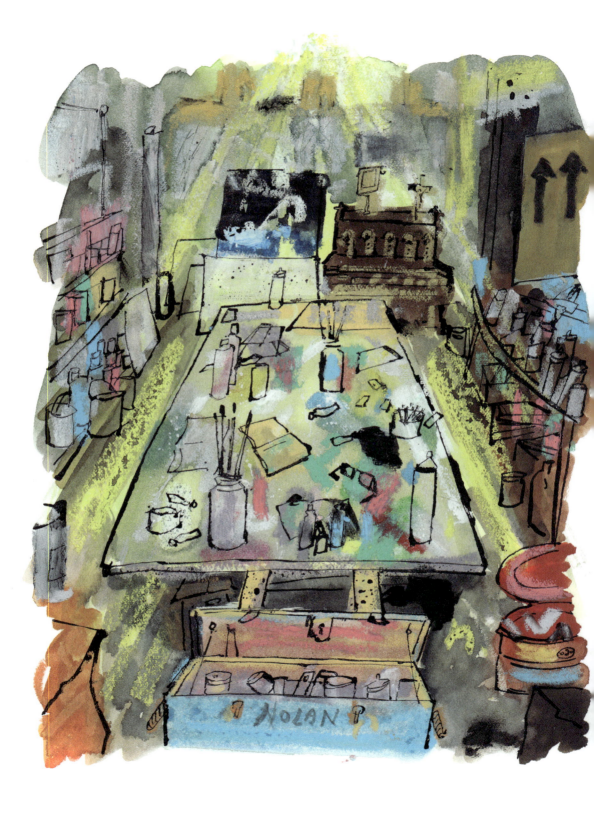

Sidney Nolan
The joy of a Thinking Room

The Rodd, Herefordshire, England

Nolan used specially adapted spectacles to work in his studio.

Australian painter Sidney Nolan (1917—92) had a successful career in his home country before moving to England in 1951. After his second wife Cynthia died in 1976, he moved out of London to picturesque rural Herefordshire and bought a seventeenth-century manor house called The Rodd near Presteigne, close to the Wales-England border, where he equipped his final, intriguing studio.

Nolan's artistic process actually started in the study of his home. Known as his 'Thinking Room', this is where he would sit and search for ideas, either sketching or flicking through his extensive collection of books, including exhibition catalogues and monographs of his own work, usually while listening to classical music. When inspiration struck, he would then head outside and work throughout the day, not usually stopping for lunch.

Initially Nolan, perhaps best known for his iconic series of *Ned Kelly* paintings (1946—47), had worked in the house. He enjoyed the medium of spray paint throughout his life, beginning in his early days in Melbourne working as a designer in a hat factory. But even though he wore special masks and goggles, Nolan found the smell from his favoured spray paints too strong for an enclosed space (which was partially protected by putting down plastic on the floor).

Luckily, the property had various outbuildings. He used one as a small studio and as a storage space for all his many materials, including spray paints (and intriguing associated sprays such as Holts Fly Squash Remover), remains of which are noticeable today on walls and tabletops inside. Here, too, was an old Vickers machine gun case from the Second World War that he brought paints from Australia over in when he emigrated and used on an ongoing basis to store handmade paints. As well as plenty of brushes in jars, the shelves also contain his supplies

of commercial Ripolin enamel paint (faster-drying than oil, but fluid, so Nolan had to apply it on horizontal surfaces such as his floor or table) and PVA glue, with which he experimented by mixing with coloured pigments to produce his own paint. The inside walls were covered with plastic to help warm the place up and keep out draughts. It was illuminated with a mercury vapour light hung from the ceiling (an odd choice since it gives off a greenish light).

For his larger abstract paintings and portraits, including ones of Benjamin Britten and Francis Bacon (see page 10), he turned to one of his larger barns. Here, he built a suspended platform to allow him to work on his horizontal canvases, sometimes using a harness suspended from the rafters to get into the right position to spray while an assistant helped to move him around. A photo of Nolan masked and goggled for spray painting during this period makes it look like he might be about to go scuba diving. Among the most intriguing artifacts are his specially adapted spectacles incorporating reversed cannibalized binoculars that enabled him to view his work from distance.

When Nolan died in 1992, his third wife Mary ensured that his last studio remained as it was during his lifetime, right down to the paint-splattered shoes he wore in the studio.

When Nolan died in 1992, his third wife Mary ensured that his last studio not only remained as it was during his lifetime, right down to the paint-splattered shoes he wore in the studio, but could become an artistic resource for others. Happily, it has developed into just that and not only can you visit these fully time-capsuled studios, you can also stay in a cottage on the property where the Sidney Nolan Trust runs an ongoing series of creative workshops, residencies, courses and exhibitions.

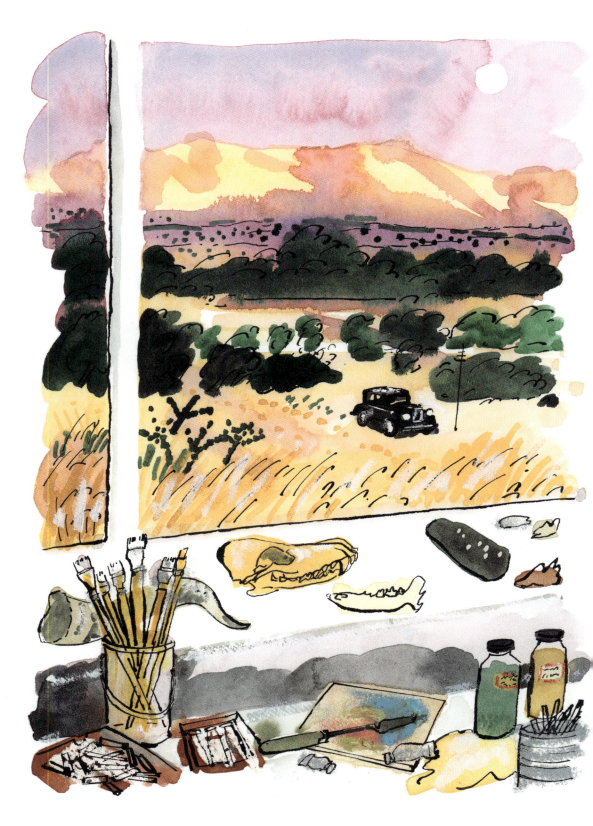

Georgia O'Keeffe
Start the day with a good breakfast

Abiquiú, New Mexico, USA

O'Keeffe enjoyed arguably the finest studio picture window in history.

'I wish you could see what I see out the window,' wrote Georgia O'Keeffe (1887–1986) to her artist friend Arthur Dove in 1942, describing her delight at her view from her studio and home in the New Mexico landscape. She goes on to describe with gentle passion the lavender sky, green cedars, purple hills, yellow cliffs and full pale moon and the feeling of space it offered her; 'It is a very beautiful world.'

The sparseness of this vista was reflected in so much of her life. She ate simply (though superbly enough for her photographer husband Alfred Stieglitz to suggest she open her own restaurant) and the shelves and windowsills in the studios and other rooms of her homes at Ghost Ranch and Abiquiu, around 100km (60 miles) north-west of Santa Fe in New Mexico, were full of the thousands of stones and bleached animal bones that she collected on her dawn walks before breakfast. Indeed, she liked the desert so much that she would often drive deep into it in her Model A Ford, a travelling studio that she nicknamed 'Hello', adjusting the front seats to face backwards and using the back seat as a makeshift easel, thus protecting herself from the beating sun as she worked.

O'Keeffe's single-storey, adobe-built Abiquiu home and studio was virtually derelict, parts of it dating back to the mid-eighteenth century, when she bought and renovated it in the early 1940s. It was an extension of the natural landscape she found so inspiring and so personally refreshing, what she called (in a good way) 'the end of the world'. Her studio, like her bedroom and sitting room, was virtually empty, with whitewashed wooden beams and a few simple chairs and tables plus a daybed for siestas, but with tremendous views, a minimalist approach described by *Vogue* as 'monastic simplicity by way of the Southwest'.

Her corner bedroom at Ghost Ranch was dominated by two glass walls that enabled her to enjoy the full expanse of the hills around her. The picture window in her studio at Abiquiu gave her a similar view. Describing her Abiquiu workspace to a friend in 1951, she explained how she kept one palette on a table with wheels and another on the windowsill, with her easel close by. A large 3m (10ft) table was covered with canvas and stretchers, and on a smaller one she kept around 300 colour cards — a kind of archive of all the painted tones she used in her work.

O'Keeffe's typical daily routine began at dawn when she got up to enjoy the sun's arrival in solitude. Then she took a half-hour walk in the desert with her dogs (keeping her walking stick handy to whack any rattlesnakes), and returned for a 7am breakfast. O'Keeffe's largely plant-based diet was modest but nutritious, so this would often be scrambled eggs, sliced fresh fruit and coffee. Bread would be homemade from organic grains. She strongly believed that a good breakfast helped to get the creative juices flowing and then worked all day in her studio with a break for lunch.

Everything that wasn't painting — working the garden, taking her dog to the vet, odd jobs around the house — she regarded as something of a tiresome disruption. 'Always you are hurrying through these things with a certain amount of aggravation so that you can get at the paintings again,' she said, describing painting as the thread of her life. She had an early dinner so she could go for another walk or drive through the countryside.

Love in the studio

On the afternoon of 30 July 1898, Rosa Bonheur entered the studio where American artist Anna Klumpke (1856–1942) — who had travelled to Bonheur's home in France to paint her portrait — was working on a large canvas. After praising her work she asked her: 'Anna, will you stay with me and share my existence?' Bonheur had lived openly with her partner and schoolfriend Nathalie Micas for decades. After Micas's death, she settled down with Klumpke and all three are buried together at the Père Lachaise Cemetery in Paris.

The studio is often a crucible for relationships. Dutch-born pianist and artist Suzanne Leenhoff (1829–1906) often modelled for her husband, the French painter Édouard Manet (1832–83). Very happily married, too, were Beatrice Philip and American-born painter James McNeill Whistler (1834–1903), who used her as the model for his *Harmony in Red: Lamplight* (1886). Indeed, Whistler was distraught at her death.

And things came to a head when the wife of American photographer Alfred Stieglitz (1864–1946) returned home unexpectedly to find him taking nude photographs of his muse, Georgia O'Keeffe, with whom he was having an affair and went on to become his wife, even though they spent much time living apart.

Not everything works out well. English painter and sculptor George Frederic Watts (1817–1904) married actress Ellen Terry, despite a considerable age difference (he was 46, Terry 16) and no real support from his friends. Sadly, they separated in less than a year and divorced, amicably, in 1877. Similarly, sculptor Camille Claudel (1864–1943) studied under and collaborated with Auguste Rodin (see page 158) for years, and they became lovers. But although she hoped that he would leave his partner Rose Beuret and marry her, he never did.

Pablo Picasso
A regal disorder

Various studios, Paris and Cannes, France

Picasso's studio followed in Balzac's formidable footsteps.

'When I enter the studio, I leave my body at the door,' Pablo Picasso (1881–1973) commented, 'and I only allow my spirit to go in there and paint.' He returned to the concept of the artist in their studio throughout his career, including *L'Atelier* (The Studio, 1928), *Ventana del taller* (Workshop Window, 1943), and his collection of drawings focusing on the studio and the model known as *Picasso and the Human Comedy, A Suite of 180 Drawings* (1953–54). In the last week of October 1955, he made 11 depictions of his Art Nouveau studio near Cannes, La Californie (followed by a twelfth the following month).

His first studio in Paris was in Montmartre, in the shabby shared ateliers of Bateau-Lavoir (so-called for its resemblance to the city's laundry boats on the Seine), followed by his workspace on Boulevard de Clichy, where he developed his cubist approach, then 23 rue La Boétie, where Joan Miró visited him for the first time in 1920, bringing a cake to break the ice.

One of his most famous works, *Guernica* (1937), was made in his studio at 7 rue des Grands-Augustins, found for him by the photographer and painter Dora Maar, and where he worked from 1936 up to 1955. Novelist Honoré de Balzac placed his painter protagonist Frenhofer's studio in the same location in his 1831 short story '*Le Chef-d'œuvre inconnu*' or 'The Unknown Masterpiece', which Picasso loved. Maar was allowed into his workspace throughout May and early June 1937 to photograph the creation *Guernica*. These shots reveal quite a dim lighting in the studio as they follow the development of the work.

His rooms here — where he lived and worked — were quite a sight. Old shoes fought for space with paintings by Modigliani and Braque, masks, hats, books, old pieces of glass, a broken coffee grinder and bits of bread and chocolate. His friend, the writer and artist Jean Cocteau, described it as a 'regal disorder'.

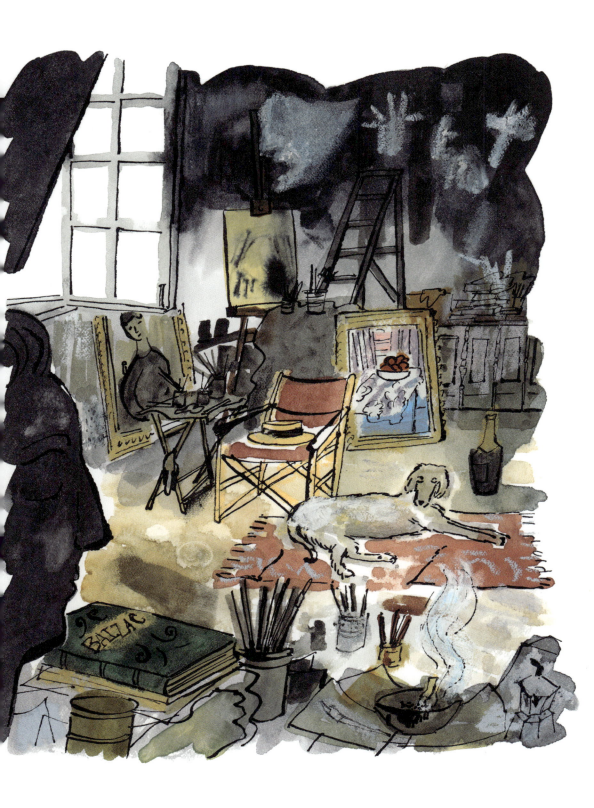

Jackson Pollock and Lee Krasner
His and hers studios

Fireplace Road, Springs, East Hampton, New York, USA

'There was no point letting the studio in the barn stand empty,' said Krasner.

When husband and wife artists Jackson Pollock (1912—56) and Lee Krasner (1908—84) became tired of urban life in New York City, they moved in 1945 to the far more rural location of a clapboard farmhouse on Fireplace Road in Springs, East Hampton. Krasner described it as an 'idyllic experience', even though it had no plumbing or central heating.

Initially they both worked in the house, but after a few months their respective studio spaces rather diverged. So, while Krasner was in an upstairs bedroom in the house working on her *Little Images* series (1946—49) on a tabletop, Pollock set himself up in a converted barn on the property. According to Krasner, Pollock slept until around 11am and tended to start work only in the late afternoon. She, on the other hand, rose at 9am because she found that morning was the best time for her to work ('while he had his breakfast I had my lunch,' she wrote). Neither would enter the other's studio without first being asked, thus visiting each other's workplace only about once a week.

Pollock emptied the barn of the previous owner's fishing equipment and repositioned it from the back to the north of the house. The barn lacked much natural light and had no electricity, so Pollock worked initially only during daylight hours (he wore jumpers when the weather turned colder) although he also later added a kerosene stove and fluorescent lighting to make working more agreeable. In 1953, after a successful sale of his paintings, Pollock 'winterized' the barn to allow all-year working, fitting new storage units, investing in insulation on the interior — that was all painted white — and adding shingles to the exterior.

The drip paintings he produced here, working with horizontal canvases, are his most famous. 'On the floor I am more at ease,' said Pollock. 'I feel nearer, more part of the painting.'

Artists' pets

Pets often provide artists with pleasant company, though none have gone as far as Dante Gabriel Rossetti (1828–82) whose house at Cheyne Walk in London was also home to an everchanging menagerie that included a Brahmin zebu bull, various armadillos, wallabies, a Japanese salamander, an Irish deerhound called Wolf, a zebra, a chameleon, a raven, a deer, white dormice, a white peacock (very short-lived), rabbits, marmots, a racoon (that hibernated in a chest of drawers), two jackasses, a Pomeranian puppy called Punch, a barn owl called Jessie, parrots, parakeets, a kangaroo and a wombat called Top that set off a wombat craze in the capital. Rossetti also considered adding an African elephant and a lion.

Not far behind him though was Frida Kahlo (see page 92) who kept a fawn called Granizo, a hawk, hairless Xoloitzcuintli dogs, two spider monkeys named Fulang Chang and Caimito de Guayabal, Bonito the Amazon parrot and an eagle named Gertrudis Caca Blanca (a reference to its abundant white droppings).

Those with a preference for cats include Henri Matisse (1869–1954, Minouche, Coussi and La Puce), Louis Wain (1860–1939, Peter), Wassily Kandinsky (1866–1944, Vaske), Suzanne Valadon (see page 170, Raminou), Gustav Klimt (1862–1918, Katze — the German for 'cat'), Pierre-Auguste Renoir (1841–1919, Grisette), and Paul Klee (1879–1940, Bimbo). Edward Gorey (1925–2000) owned half a dozen cats at any one time, but no more than that as he felt that 'seven cats is too many cats'.

Dog lovers include Norman Rockwell (1894–1978, a stray beagle mix, Pitter, and a Spaniel mix, Butch), David Hockney (see page 80, dachshunds Stanley and Boodgie), William Hogarth (1697–1764, Trump, a pug), Edvard Munch (1863–1944, Bamse, a Saint Bernard; Boy, a Gordon Setter; and Fips, a Fox Terrier), Georgia O'Keeffe (see page 138, Chow puppies), Jackson Pollock (a German Shepherd mix named Gyp and a poodle called Ahab, plus a crow called Caw-Caw), Charles Schulz (1922–2000, Spike, the inspiration for Snoopy), René Magritte (see page 108, Loulou, a Pomeranian), Lucian Freud (1922–2011, Pluto, a whippet).

Andy Warhol (see page 180) had a foot in both camps with his cats Hester and Sam plus a dachshund, Archie. So did Pablo Picasso (see page 142), with his dachshund Lump, Boxer called Yan, and a Siamese cat, Minou, not to mention a goat, Esmeralda.

In keeping with his brand, Salvador Dalí (1904–89) had two ocelots, called Babou and Bouba.

His work in the barn, big enough to work on canvases from all four sides, was recorded in 1950 in a series of 500 photos and two films by photographer Hans Namuth. These concentrated on Pollock's painting process and showed how thoughtful it was, not merely hurling liquid house paint randomly onto a canvas. While this brought Pollock to a wider audience, he was not happy with the results, which he felt had become intrusive and damaging to his process.

Krasner only started working in the barn herself a year after Pollock died, having previously moved from her bedroom studio to a converted former smokehouse on the grounds. He had only worked in the barn for three years, but she enjoyed 27 inside. 'There was no point letting the studio in the barn stand empty,' she said. Unsurprisingly, the size of her paintings grew, reaching over 4m (13ft) long, and she was also able to work on more than one painting at a time. Among the works she created there were her *Earth Green* (1956–59) and *Night Journeys* (1959–63) series. Although she left details for the property to be turned into a museum, she was clear that she did not want any other artists to work in the barn studio and so it has become an exhibition space.

Remarkably, not only can you visit the barn studio and view some of Pollock's opened paint cans and brushes, you can even walk on his artistic debris. When it was winterized, a new surface was added to the studio's floor and when this was accidentally discovered and taken up, the original floorboards were happily found to be still in place. These were covered with the splatter that spilled over the edges of Pollock's poured paintings. Treated by conservators, a restricted number of visitors (wearing the padded shoe coverings provided) can now walk across these remains. The restoration work revealed not only some of his footprints from walking barefoot across a canvas, but also that the floor served as a kind of palette for mixing colours.

Paula Rego
A place to feel best in

Rochester Place Mews, London, England

Rego's studio: Full of things would be an understatement.

'My studio,' said Portuguese visual artist and women's rights campaigner Paula Rego (1935–2022) of her workplace in London's Kentish Town, 'is full of things.'

It certainly was. Rego filled it with props for her work, from model foetuses (a pointer to her firm stance in favour of abortion) and a huge purple octopus, to mannequins dressed in Victorian clothes, stuffed animals (such as a monkey in a blue dress), toys, crockery, papier-mâché puppets, racks of costumes and dolls in many forms and shapes. Visitors described the studio variously as a 'playroom', 'theatre backstage', 'chamber of horrors', 'an explosion at a car boot sale' and 'like walking into her mind'.

A keen reader, storytelling was at the heart of what she did. Using these items as inspiration, she constructed scenes that she then drew, before embarking on the finished work, almost always in pastel, but also using crayon, charcoal and collage techniques.

Rego had earlier studios, including an upstairs room in her London home and a shed at the bottom of her garden. But her favourite was in Rochester Place Mews, beside a garage, opposite a block of flats, and handily not far from a theatrical hire shop. It was built at the turn of the twentieth century and, before Rego arrived in 1993, had been used to make hospital stretchers. Light into the white-walled, windowless space was via enormous skylights in the ceiling.

Rego took great delight in her studio where she had a bed installed on a platform for afternoon napping. 'It's the place I feel best in,' she said. 'It is where I belong.' In her eighties she was still working most days, beginning around 10.30am to the sounds of opera, taking a siesta after lunch (usually salad with ham or cheese), and working to the sounds of Portuguese fado or Bing Crosby, then finishing about 6.30/7pm in time for a glass of champagne and to get home to see *EastEnders*, which she loved.

Rembrandt van Rijn
An artist's inventory

Jodenbreestraat 4, Amsterdam, Netherlands

Not all artists leave a huge paper trail behind them. Although Eugène Delacroix (see page 58) and Piet Mondrian (see page 126) frequently mentioned their studios in their writings, Dutch golden-age painter Rembrandt van Rijn (1606–69) left no memoir, no journal and only half a dozen letters, none of which contain any keys to understanding his workspace. What we do have, happily for us if less happily for Rembrandt, is a detailed inventory of everything in his house when he filed for bankruptcy in July 1656.

Like most artists of his time, although Rembrandt had a studio (north-facing, three-windowed), his working life spilled out into his home in general. So his central-Amsterdam workspace was used as a place to eat and sleep as well as a showroom, teaching area and gallery — his eighteenth-century biographer Arnold Houbraken says Rembrandt used to yank people back from looking too closely at his pictures by telling them that 'The smell of paint will bother you'.

So his central-Amsterdam workspace was used as a place to eat and sleep as well as a showroom, teaching area and gallery.

The inventory lists a large collection of his own art in his studio and other rooms, including sketches of animals that he kept as study material, as well as works he attributed to Raphael and Michelangelo, and an album of 'curious miniature drawings', possibly Indian Mughal miniatures. These all formed his own image library.

But over the two decades he lived in the house, Rembrandt also built up a large collection of odds and ends. So in his *Kunst Caemer* or art room, also referred to as his 'Cabinet of curiosities', in addition to plenty of artworks, there were objects from around

Rembrandt's inventory included calabashes, cuirasses and coral.

the world that he used as inspiration for his work and teaching. This list includes:

> A dozen busts of the Caesars
> Two terrestrial globes
> A small box of minerals
> An East Indian sewing box
> Two porcelain cassowaries
> A Japanese helmet
> Specimens of land and sea animals
> One net with two calabashes, one made of copper
> A great quantity of shells, including coral branches
> A hand gun
> A rare, ornamented iron shield made by Quintijn de Smith
> A Turkish powder horn
> A cabinet with medals
> Several walking sticks
> A longbow
> A Chinese bowl containing minerals
> A large lump of white coral
> A bird of paradise
> Six fans
> A small marble ink stand

Meanwhile in his small studio we find:

> Sixty pieces of Indian hand weapons, arrows, shafts, javelins and bows
> Bamboo wind instruments
> A quantity of antlers
> Four crossbows and footbows
> Five antique hats/helmets and shields
> Nine gourds and bottles
> A small metal cannon

And in the large studio:

> Halberds, swords and Indian fans
> Costume of an Indian man and [another of a] woman
> A giant helmet
> Five cuirasses [breastplate armour]
> A wooden trumpet
> A skin of a lion

What the inventory does not include are his artists' tools, paint, brushes or easels, since these were crucial to him continuing his profession and so immune from creditors.

The otherwise distinct lack of documentation has not prevented the Rembrandthuis (Rembrandt House Museum) in Amsterdam from doing its very best to recreate for visitors what it was like when Rembrandt lived here at Jodenbreestraat 4, and to offer artists residency opportunities to work in the original studio space.

Faith Ringgold
A studio to inspire a story

Jones Road, Englewood, New Jersey, USA

Ringgold's studio was part of a long walk to freedom.

American painter and fabric artist Faith Ringgold (1930–2024) had a number of New York studios, from her first in 1950 in her Harlem apartment at Edgecombe Avenue, through the Spectrum co-operative gallery in Manhattan in 1967 where she produced parts of her hard-hitting *American People* series, to her 1991 studio in the Garment District. But the one she had built in the attic of her home on Jones Road in Englewood, New Jersey, played a notable part in her life. When she moved to the area in 1992, Ringgold says it was her dream to build a studio. Neighbours were less keen and objected, Ringgold commenting that: 'I discovered that I was surrounded by hostile neighbors, who saw my presence on Jones Road as a threat to the "quality" of their lives.' It took a six-year struggle to convince planners and obtain the necessary permits to fulfil that dream.

To mark the completion of the studio in 1999, she decided to produce a work of art, opting for a subject that honoured her ancestors whose journeys out of slavery had enabled her to be free and tell their story in her own voice. In the *Coming to Jones Road* series, mixed-media works using quilted fabrics and paintings took a historic look at her ancestors' experiences. The piece *#4: Under a Blood Red Sky* (2000) shows a group of black figures — including a newborn baby named 'Freedom' — walking along a road through trees underneath a chalk-white moon and the eponymous sky, their story told through text in the border. It harks back to her 1991 painted quilt *Picasso's Studio* that reworked his *Les Demoiselles d'Avignon* (1907) imagery to feature the fictitious story of African-American expatriate Willia.

Ringgold remained active into her nineties in her Englewood studio where framed quilt editions from *Coming to Jones Road* hang on the walls. The studio looks out onto the garden she commissioned, which inspired some of its imagery.

'I have never had a studio, and I do not understand shutting oneself up in a room. To draw, yes; to paint, no.'

Claude Monet

'The studio is a laboratory, not a factory.'

Chris Ofili

Auguste Rodin
A studio of snow

Pavillon de l'Alma, Meudon, France

Rodin worked in a 'vast hall filled with light'. And plaster casts.

In the mid-1890s Auguste Rodin (1840–1917) relocated from central Paris to the leafier, nearby spot of Meudon. In 1901, in the grounds of this new home — the Villa des Brillants — he relocated something else, the Pavillon de l'Alma. This was a mainly glass structure with high arched windows that Rodin had designed and built for the Paris Exposition Universelle of 1900. His solo exhibition inside it had cemented his reputation and it now became his main studio.

It needed to be big since Rodin worked with dozens of assistants (including Constantin Brâncusi, see page 32), although there were other smaller studios dedicated to cutting stone and firing clay. Rodin supervised the work but did little actual carving, although he liked to be photographed with tools and covered with dust.

German poet Rainer Maria Rilke worked as Rodin's secretary in 1905 for several months. In a letter to his wife Clara in 1902, he described the studio as a 'vast hall filled with light where all these dazzling white figures looking out at you from high glass doors, like creatures in an aquarium'. There were plaster casts strewn everywhere, bits of arms, leg, hands in a variety of poses and torsos, as well as huge showcases filled with Rodin's unfinished masterwork *The Gates of Hell* (1880–1917). In addition, there were tables, stands for models and chests of drawers covered with the brown baked-clay figures that Rodin created as the first stage in his sculptures.

George Bernard Shaw described sitting for a portrait by Rodin in his studio: 'The most picturesque detail was his taking a big draught of water into his mouth and spitting it onto the clay to keep it constantly pliable. Absorbed in his work, he did not always aim well and soaked my clothes.'

The pavilion was demolished in 1926.

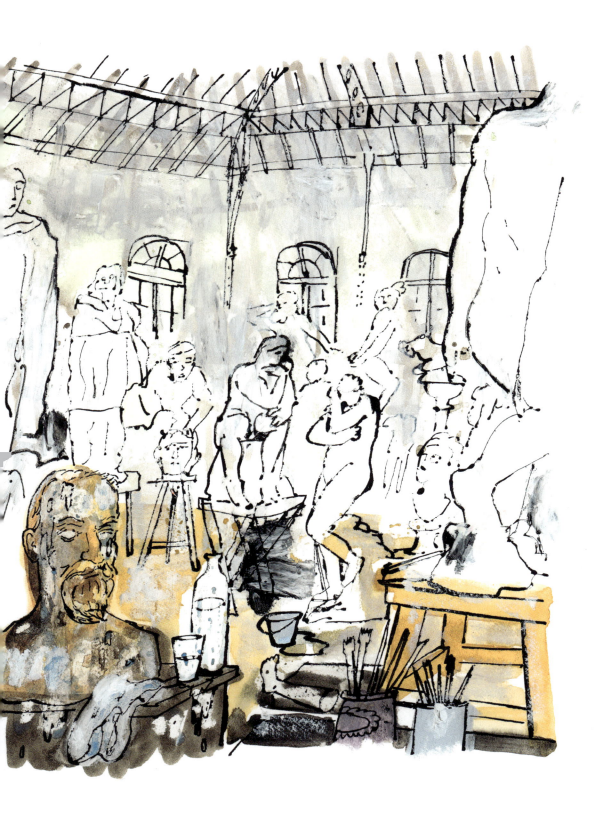

Jenny Saville
A laboratory of ideas

Oxford, England

Saville's studios, from Palermo to Oxford via New York.

Jenny Saville is perhaps best known for her enormous canvases depicting the female nude, the size of which would have been impossible to produce in her first studio (literally a broom cupboard from which her siblings were banned when she was aged seven) and has even required the minor dismantling of ceiling tiles in more recent studio incarnations to fit the canvases in.

In between she has worked in New York, Glasgow and London, not to mention a dilapidated 21-room eighteenth-century palazzo in Palermo complete with frescos, as well as the back of a parked truck during the pandemic lockdown. She now lives in Oxford, where her painting studio is a low-ceilinged 1,050m² (11,300 sq ft) space in a central location.

Her routine here has been adjusted to fit around looking after her children, working during school hours, breaking on their return and returning to the studio later in the evening when they are in bed to work until midnight or 1am. The quiet is partly punctuated by the music she plays, usually not during the day, but at night Beethoven, Philip Glass, Radiohead and Jay-Z help to get her in the mood. She regularly has several works on the go at one time, keeping track of what stage she has reached on each by adding notes to them, a process she extends by writing up a report on each as it is finished to help her improve her work.

A Francis Bacon-esque spread of images is dispersed around the walls and floor (the latter splattered with paint, which she calls 'accidental paintings', and photographs). These include reproductions of works by Velázquez and Michelangelo, Victorian photographs and art history books opened at inspirational pages. When she was working on her 2019 *Self-Portrait (after Rembrandt)* she kept Rembrandt's *Self Portrait with Two Circles* (c.1665–69) stuck around the edges of her painting. Indeed, she has described her studio as a 'laboratory of ideas'.

Yinka Shonibare
Helping the next generation of artists

Broadway Market, London, England

Shonibare: from carpet warehouse to studio.

British-Nigerian artist Yinka Shonibare's (1962—present) varied multimedia work focuses on themes of colonialism, class, race and what he describes as the 'tangled interrelationship between Africa and Europe'. He has two studios, a small, quiet garden office at his home in Victoria Park that he uses mainly for brainstorming, reading and drawing, and a larger one that is the centre of design activity. This is a former carpet warehouse in Broadway Market, East London, with a view of the Regent's Canal.

When he took it on, Shonibare had the roof space opened up and took the dividing walls within it down. Though it still retains a warehouse feel, it now has a large skylight and modern furniture designed by David Restorick. In the past, Shonibare worked every day until midnight or the early hours, but over the last decade he has only gone into the studio three days a week, which he has found has made him far more productive.

In his late teens Shonibare became ill with the spinal disorder transverse myelitis and this left him partly paralyzed. He now uses an electric wheelchair and a team of assistants help to bring his ideas to completion. Because of this, part of his morning is spent on exercise before working on admin and planning, and then getting down to work in his studio.

In 2006, Shonibare launched Guest Projects, a special project for young artists in the ground floor space of his main studio. Realizing the problems that young artists, especially more experimental ones, have in finding work and gallery space in London, this scheme offered them somewhere free as a base. Applications for monthly residencies could be posted by artists via a proposal box outside the building. Since the Covid-19 pandemic it has extended online to provide digital support and mentoring. Shonibare has also founded two creative projects in Nigeria that encourage art, agriculture and ecology in the country.

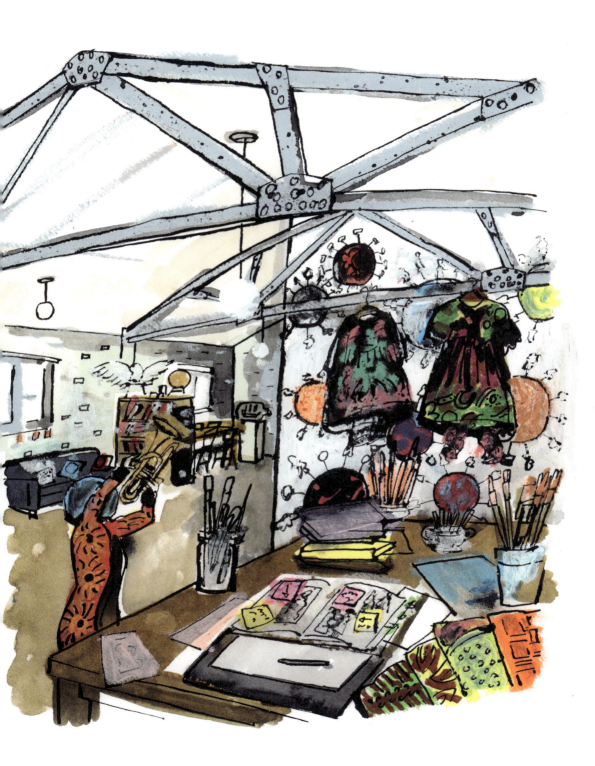

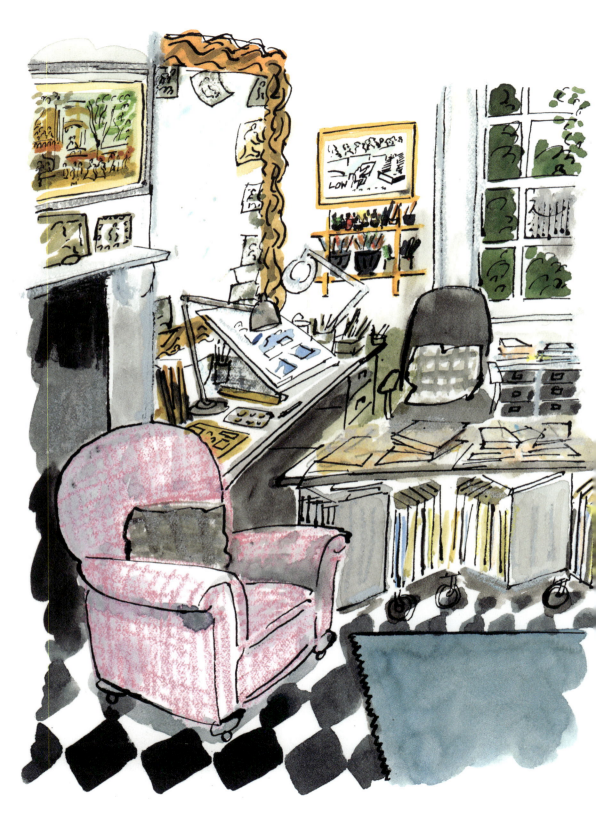

Posy Simmonds
Three pieces of inspiration

Islington, London, England

A large mirror is a key element in Posy Simmonds's studio.

All studios reflect the artists inhabiting them and cartoonist and graphic novelist Posy Simmonds's (1945—present) basement workroom in Islington, London, is no exception. Here are three key items from the room that offer an insight into her work:

David Low cartoon
Simmonds was a keen reader of comics as a child. Favourites included the *Beano*, *Dandy*, *Topper*, *Eagle*, *Girl*, *Swift*, *Robin* and plenty of American comics, since she lived near a US airbase as child, so had access to American comics such as *Blondie*, *Superman* and *Casper the Friendly Ghost* via her forces family schoolfriends. The smell of the pages' ink remains a strong memory for her.

She also enjoyed the complementary combination of pictures and words that she came across in the family's bound copies of *Punch* magazine, stretching back into the nineteenth century — these bookshelves also held collections of the work of Carl Giles via his annuals, underrated cartoonist Graham Laidler known as 'Pont', and Ronald 'St Trinians' Searle.

For many years a drawing by political cartoonist David Low, who made his name during the Second World War, hung on the wall to her right, close to her drawing desk. His 1956 pen and ink *The Cartoonist's Material — Yesterday and Today* depicts a cartoonist at work by a drawing board, using a tailor's dummy to bring the major leaders of the day to life. Simmonds donated it to the British Museum in 2020.

Mirror
Simmonds's studio leads into her small garden. The room is neat, with good-sized windows offering her plenty of light, and full of the tools of her trade: pots of pens and brushes, magazines stored in rolling cabinets designed and made by friends (though a damp

problem badly affected her collection of *Vogue* magazines), as well as a comfortable armchair. There are also weights that she uses following a fall some years ago. She aims to draw every day and constantly doodles — she is ambidextrous, favouring her right hand for drawing, her left for sharpening pencils.

Above Simmonds's drawing board is a large square mirror, given to her by her husband one Christmas. She uses this to act as her own model, helping her refine the poses of her characters, the looks on their faces, their gestures and indeed their entire personality as they run the full gamut of emotions. She also has a full-length mirror in the hall that she also uses to ensure she gets her characters' positioning correct (on one occasion she used it when working out how one of her nastier creations would kick a small dog, a cushion standing in for the canine).

This dedication to authenticity is one of the pillars of her success. For major serials like *Tamara Drewe* or *Gemma Bovery*, she begins the characters' evolution in a Bushey sketchbook made by C. Roberson and Co.

She aims to draw every day and constantly doodles – she is ambidextrous, favouring her right hand for drawing, her left for sharpening pencils.

Rowlandson watercolour

Although the words in her work are obviously important, it's the images that come first. Indeed, these sketchbooks are crammed with drawings of people, many of them drawn from life ('I'm like a film director and sketchbooks are my casting couch,' she says), and often from Simmonds's wanderings through London and on the capital's buses.

This is why Thomas Rowlandson's *Vauxhall Gardens* (1785), also hanging on the walls of her studio, has such resonance for Simmonds. Like fellow satirists and cartoonists Rowlandson and William Hogarth, whom she describes as her 'particular gods', Simmonds's interest is in the mores and fashions of contemporary society. Vauxhall Gardens was a hugely popular eighteenth- and nineteenth-century pleasure garden in south

London that attracted the great and the good. Rowlandson's watercolour depiction of it features many of its regulars, such as Dr Samuel Johnson and James Boswell, Oliver Goldsmith and the Prince of Wales before he became George IV. Interestingly, an early sketch of this print included Rowlandson himself, sketching the scene.

Joaquín Sorolla
Working inside and out

Paseo del General Martínez Campos, Madrid, Spain

Sorolla: a studio garden of one's own in sunny Madrid.

Spanish painter Joaquín Sorolla (1863–1923) — dubbed the 'Master of Light' by Claude Monet — was at his happiest when he was working in the open air. A photograph of Sorolla on the beach in Valencia shows him protected by windbreaks and an umbrella, working away at an easel (that he tied down to keep canvases from being blown away). This was a kind of portable studio, complete with paint box that also served as a palette.

For a man who was not keen on working in a traditional studio, Sorolla had a splendid one at his home in Madrid that he designed himself. The studio has high ceilings and plentiful skylights and, in his day, his own paintings virtually covered the walls, leaving barely any space. In Sorolla's lifetime there were also various textiles on the walls, sadly none of which survive, nor does the large rug that lay on the floor. In the few spaces on the walls he also tacked small oil sketches made on pieces of cardboard that he called 'colour notes' — he worked on these smaller studies on location, then finished them up in his studio. Happily still intact and in place is his remarkable day bed, a kind of small-scale four-poster with velvet drapes and a canopy.

Not only did Sorolla design the house, he also planned the lovely grounds around it that feature frequently in his work, such as *Courtyard of the Casa Sorolla* (1917). Divided into three separate areas, it was particularly inspired by the Andalucian gardens he had visited and painted in Seville and Granada, with marble fountains, statues, running water, formal hedges of box and myrtle and blue and white tiles. These tiles are clearly shown in his 1919–20 *Clotilde in the Garden* where the tiled edging contrasts with a swathe of pink wallflowers. One of his last paintings is of the garden, showing the wicker chair in which he used to sit and work, empty.

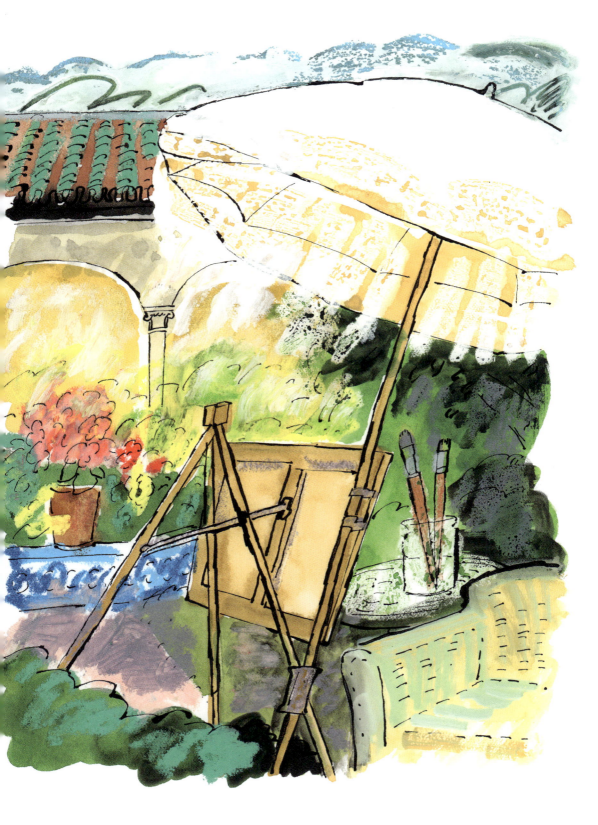

Suzanne (Marie-Clementine) Valadon
The heart of Montmartre

12 rue Cortot, Paris, France

Valadon shared her studio with a goat, a cat, and plenty of drink.

As a muse and model from the age of fifteen for the likes of Berthe Morisot and Amedeo Modigliani (see page 122) Suzanne Valadon (1865–1938) was much in demand. She had a close relationship with Henri de Toulouse-Lautrec — who bestowed the name 'Suzanne' on her — and acted as co-host at his soirées.

Valadon became a single mother at the age of eighteen. Gossip suggested Pierre-Auguste Renoir or Edgar Degas, both of whom encouraged her to paint, may have been the father but she never revealed the truth. Her life changed dramatically in 1896 when she married long-time lover Paul Moussis. Moussis was a banker and sufficiently wealthy to pay for Valadon to run her own studio in Montmartre at 12 rue Cortot.

It was an ideal space, with its large north-facing window, glassed roof/skylight and mezzanine-loft area. Previously it had been used by Renoir and Émile Bernard, and later would be the workspace of Raoul Dufy. The arrangement worked well until Moussis discovered that she had taken a lover and in the consequent divorce she temporarily lost the studio. She returned to it in 1912 and stayed until 1926, this time with her son Maurice, a successful painter himself, and her much younger lover, André Utter, an artist friend of her son's. A goat (to which she is said to have fed her unwanted drawings) and a favourite orange tabby cat completed the family, but their boisterous life together with its loud arguments and heavy drinking became infamous and they were nicknamed the 'Infernal Trinity'. She and Utter also earned some notoriety by posing nude for each other.

The studio and neighbouring apartments have now been restored and are the centrepiece of the Musée de Montmartre. It is something of a recreation; although the physical space is the same as it was in Valadon's day, apart from the stove, chair and some panelling, hardly anything that visitors see in the space is original.

Vincent van Gogh
The dream of a little white studio

Place Lamartine, Arles, France

Van Gogh dreamed of an ideal studio set-up with Gauguin.

In May 1888, Vincent van Gogh (1853—90) was hugely optimistic about his sunny new studio in Arles in the south of France. Just 12 months later, he was painting from the less salubrious surroundings of a studio in an asylum.

Tired of Paris, Van Gogh moved down to Arles in February 1888 and in May into the building on Place Lamartine that he immortalized in his painting *Het gele huis* (The Yellow House, 1888) or *De straat* (The Street, 1888). His plans for it were ambitious. Rather than merely a run-of-the-mill home, he told his brother Theo in a letter that he wanted it to be a 'living studio', a workspace in which a collective of like-minded artists could paint and live together, away from the pressures of the capital.

On 1 May 1888 he wrote to Theo describing the four rooms he had rented in the building that was painted yellow outside and whitewashed inside. Upstairs were his living quarters and downstairs were his studios, with a paved red brick floor and plenty of sun flooding through the windows. 'I have one big worry less,' he said, 'now that I have found the little white studio.'

By August he told Theo that he'd be happy forever with a small allowance and the peace and quiet that his studio afforded him, and that he felt he'd really landed on his feet. At this point, he explained to his sister Willemina that he was thinking of decorating his studio (a term he often used to describe the entire building) entirely with paintings of sunflowers, but also asked Theo to send him various Japanese art prints, and others by Daumier, Delacroix and Géricault in the meantime. Another letter in September reveals he was hard at work, regularly up at 7am to start painting and barely stopping until 6pm.

Although he hoped many artists would come to enjoy the Yellow House (since demolished after it was badly bombed by

an Allied plane in June 1944), he was particularly keen that Paul Gauguin join him there. Slightly reluctantly, he did so for a couple of months from October 1888. While it was productive — Van Gogh wrote to Theo that they had been working all the time and getting to bed early after dinner in the local café — it was also a stormy relationship and ended when Van Gogh mutilated his own ear in late December. After a brief spell in hospital and a return to the Yellow House, his plans for an artists' collective in tatters, he voluntarily entered an asylum in nearby Saint-Rémy-de-Provence in early May 1889.

Fortunately, not only was he permitted to continue painting in the asylum, he was allowed an unused room adjoining his

bedroom to use as a studio. It was here that, during a very creatively fertile period, he painted the bright *Window in the Studio* (1889), with bottles standing on a deep windowsill and his own paintings on either side of the eponymous barred window, looking out onto a view of the garden outside in which Van Gogh also regularly worked.

It was not always a happy time for him — he tried to poison himself by eating his own paints — but more optimistically he wrote to Theo not long after his arrival that he was pleased to be living there and that 'the change in surroundings will do me good'. To his sister-in-law Johanna, he said he had never been as peaceful before and was looking forward to resuming his painting.

Critics

Once a work is finished, it not only awaits the verdict of the public, but also the gaze of the critics. Sometimes this can be harsh.

'Saw Millais' "Carpenter's Shop" at Ryman's,' Charles Dodgson (a.k.a. Lewis Carroll), wrote in his diary on 13 June 1862. 'It is certainly full of power, but hideously ugly: the faces of the Virgin and Christ being about the ugliest.' Carroll was not alone in his dislike of *Christ in the House of his Parents* by English painter Sir John Everett Millais (1829–96), which *The Times* described as 'revolting'. In his magazine *Household Words*, Charles Dickens pronounced that the depiction of Mary was 'horrible in her ugliness'.

Equally harsh, yet unintentionally influential, was Louis Leroy's writeup for *Le Charivari* magazine in Paris in April 1874 of the first exhibition by the Société Anonyme des artistes, peintres, sculpteurs, graveurs, etc. His review of works by Claude Monet, Camille Pissarro ('It's a dog's dinner'), Alfred Sisley, Edgar Degas and Paul Cézanne made sarcastic use of the term 'impressionists', a term that immediately stuck and was soon used by the artists themselves.

Of course, sometimes the criticism is positive. In February 1890, Vincent van Gogh wrote a letter to French art critic Albert Aurier thanking him for the kind words about his work in an article for the magazine *Mercure de France*. At that point, Van Gogh was in the asylum in Saint-Rémy, but promised Aurier that he would send him more of his paintings as a personal thank you.

Kara Walker
A creative haven

Industry City development, Brooklyn, New York, USA

Kara Walker's studio: 'music is intrinsic'.

Kara Walker's (1969–present) single-minded and sometimes provocative concentration on exploring the history of race and sexuality in America's past and present has mainly been through her exquisite, if often very unsettling, cut-out paper silhouetted figures. Indeed, her work has often been controversial, and in the 1990s Walker experienced an early example of cancel culture following a campaign from a fellow artist who strongly disagreed with how she was exploring the black experience of the pre-civil war American south.

Walker's father, Larry, is also an artist as well as an emeritus art professor at Georgia State University. When she was a young girl, Walker sometimes informally dropped in on her father's drawing classes and his studio in the family's garage. Despite her young age, she dates her desire to become an artist from this time.

Wherever she works, Walker has needed space to work on her trademark wall-sized silhouettes as well as installations (such as her *The Katastwóf Karavan*, 2018, a steam organ inside a full-sized steel-wrapped wagon decorated with her signature silhouettes), sculptures, and films such as her 2011 *Fall Frum Grace, Miss Pipi's Blue Tale*, which was filmed in her studio.

Walker worked for some time in a studio with a large personal library of books in the Garment District of Manhattan. From here, she had marvellous views of the Empire State Building. But, dismayed at the spiralling rental charges (and with a desire to be nearer her home in Brooklyn), she moved in 2017 to a larger space in the Industry City development in Brooklyn, a waterfront complex of former warehouses that is home to a wide variety of creatives (her view here is of the Statue of Liberty and the Ikea loading dock). This is a huge open workspace with white walls, a small bay area used as an office, a kitchen and areas for her assistants.

The studio is a creative haven for Walker who has talked about her fears of losing control and how her studio — and sketchbook — provides her with a safe place where she can operate successfully. The walls are decorated with photos by her partner and collaborator, the photographer Ari Marcopoulos, including one of Jean-Michel Basquiat (see page 14) in his bath. In fact, the couple first met when Marcopoulos photographed her in her Garment District studio.

The studio even provided the content for her 2021 show *A Black Hole is Everything a Star Longs to Be*. This was made up of hundreds of her drawings (charcoal, ink, chalk), watercolours, collages, pages of handwritten text and notes, newspaper clippings and advertisements from the personal archive she kept in her workspace over nearly three decades. It was mostly not created intentionally for display, rather a peek into her working process, or as she has described it, an 'excavation'.

The studio is a creative haven for Walker who has talked about her fears of losing control and how her studio — and sketchbook — provides her with a safe place where she can operate successfully.

Walker's daughter Octavia Bürgel, herself an artist, put together a Spotify playlist called Sounds from the Studio to run alongside the exhibition, writing that 'In Kara Walker's studio practice as in her personal life, music is intrinsic … Walker's taste can be described simply as eclectic.' The playlist pulls together some of her mother's favourite tracks from her large record collection, including Ella Fitzgerald's 1960 recording of 'Summertime' by George Gershwin, 'Whitey on the Moon' by Gil Scott-Heron and Grace Jones's 'Slave to the Rhythm'.

Andy Warhol
Mixing work and pleasure in the studio

231 East 47th Street, New York, USA

Enthusiasm was the key to success in Warhol's studio.

Between the mid-1960s and mid-1980s Andy Warhol (1928–87) relocated what was dubbed the 'Factory' several times around New York City. But it was the fifth-floor loft location at 231 East 47th Street that he moved into in January 1964 that was his most famous studio.

A former upholstery workshop, it was a cavernous, industrial space with four cast-iron pillars and various arches, about 3.5m (11½ft) high, and walls of exposed brick. 'Basically crumbling' was how Warhol described it. It was reached by a freight elevator — a short black and white film exists of writer Susan Sontag negotiating the trip up from the street to the studio. In addition to a main open-plan central space, there was a bathroom and a darkroom for developing photographs. Warhol estimated the studio measured about 15 x 30m (50 x 100ft), though it was probably actually a little smaller.

What was most striking about it was the decoration. Warhol asked theatre lighting designer William Linich (known as Billy Name) to cover everything in silver paint or aluminium foil: ceiling, walls, pipes, chairs, even the telephone and toilet bowl. 'It was a perfect time to think silver,' said Warhol, who described it as the past and the future, representative of both the silver screen of Hollywood and the silver suits of astronauts. 'And maybe more than anything else,' he added, 'silver was narcissism.' Name also painted the floor silver, indeed repainted it regularly because of the constant footfall. The windows, however, were simply painted black to keep natural light out — unsurprisingly, visitors remarked on how dark the studio was. The whole thing took Name several months. He described the result, known as the Silver Factory, as a 'sculpture'.

In addition to all the materials needed for the constant silk-screening production line, there was considerable artistic debris,

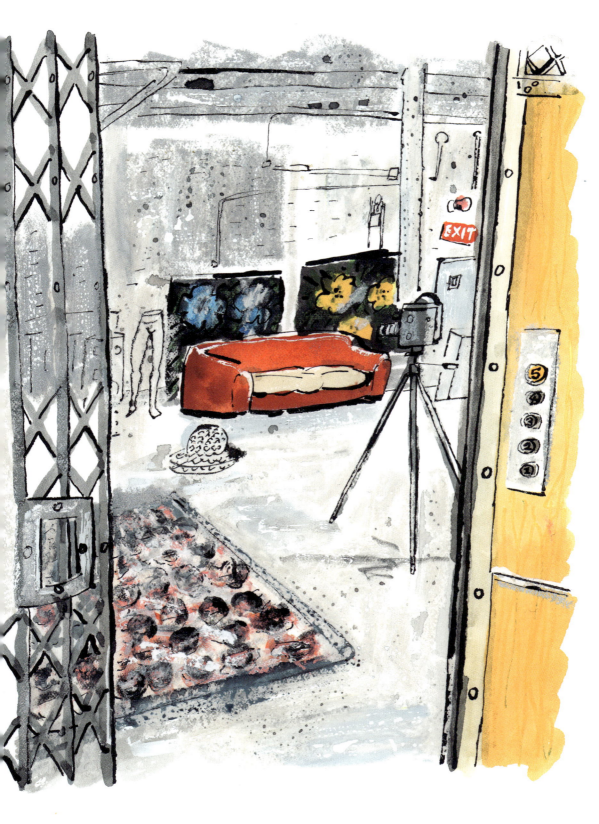

including a long red couch (found unwanted on the sidewalk outside the YMCA across the road and dragged up to become an iconic addition to the Factory), many magazines and newspapers, a large disco ball, the bottom half of a mannikin and various installations in progress at any one time.

Warhol worked at his art in this space, sometimes alone, but also with assistants, up to 15 during the production of his *Flowers* silkscreen series in the summer of 1964. But the Factory was

Art in space

Traditional studios have had a good innings, but for nearly 60 years we have been producing art that is literally out of this world. The first work to be produced in space was created on board the *Voskhod 2* spacecraft on 18 March 1965. Russian cosmonaut Alexei Leonov (1934–2019) returned to the capsule after a spacewalk and, with a packet of coloured pencils, sketched *Sunrise*. This image of an orbital sunrise is made up of a number of black, red, yellow and blue colour arcs in the shape of a rainbow with a small red ball in the centre.

The first selfie in space was taken only a year later by Buzz Aldrin (1930–present) during a spacewalk, or EVA, on the four-day *Gemini 12* mission. Using a modified Hasselblad, he also managed to include the blue curve of the Earth in the background.

We are also starting to send our art out into space. Astronauts on the *Apollo 15* mission that landed on the Moon in July 1971 smuggled on board a 9cm (3½in) stylized sculpture of an astronaut by Belgian artist Paul van Hoeydonck (1925–present). Erected on the ground surrounded by footprints, *Fallen Astronaut* commemorated all the Russian and American astronauts and cosmonauts who had died while on service. It was made of a particularly hardwearing and light type of aluminium called Metalphoto.

Further afield, an example of Damien Hirst's (1965–present) signature spot works became the first artwork on Mars on Christmas Day 2003. Made up of 16 coloured dots using minerals such as azurite (blue), molybdenum (yellow) and titanium oxide (white), it was used as an instrument calibration chart on board *Beagle 2* and looks like a small watercolour paintbox.

very much a centre of collaborative creative activity in general, becoming a hangout and rehearsal space for musicians such as the Velvet Underground and a place for shooting short, often pornographic, experimental films, several of which featured the red couch. Warhol saw it more as an artistic laboratory rather than a straight one-person studio. It also served a very social role, an avant-garde playground where the great and good, from Mick Jagger to Salvador Dalí, visited simply to hang out and be seen.

 The general working atmosphere was decidedly bohemian; Warhol's main requirement of his fellow artists being solely enthusiasm. Still, some kind of 'regular' working routines developed. Gerard Malanga, one of Warhol's closest associates, said that on a typical Factory working day Warhol would arrive around noon, work until about 6pm, and then go out to socialize. Warhol, on the other hand, said they usually worked until midnight before going to hang out in the fashionable Greenwich Village area of the city, heading home about 4am to sleep and returning to the Factory by early afternoon.

 Warhol moved from the Silver Factory in 1967 to a similar space, the sixth floor of the Decker Building at 33 Union Square West. If anything, the wild atmosphere was ramped up even more here with an eclectic group of drag queens, heiresses, musicians and actors making up a kind of court known as the Warhol Superstars. This workstyle came to an end the following year when Warhol was shot by writer Valerie Solanas. He consequently restricted access to his work hub that he then started to run much more like a traditional business.

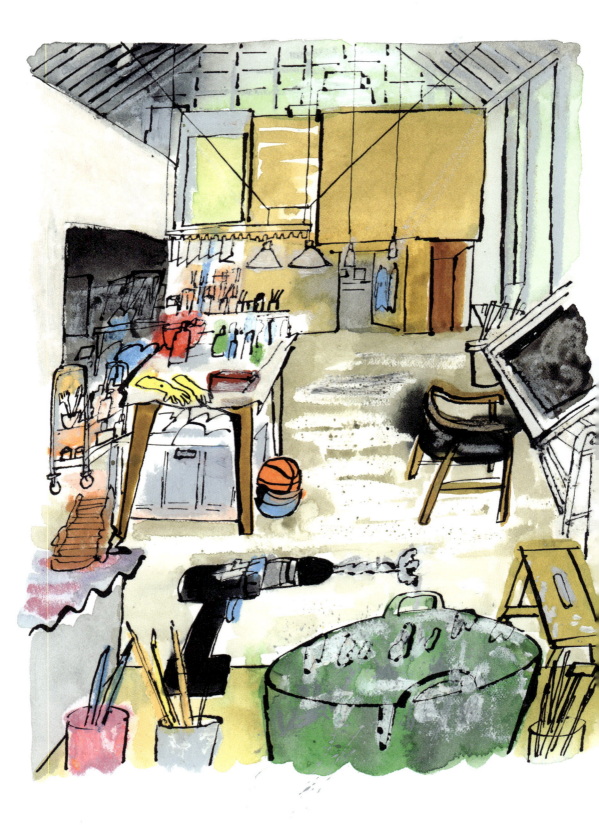

Rachel Whiteread
A place to mummify the air

Various studios, London, England

Rachel Whiteread: a lifetime of creating studios.

Sculptor Rachel Whiteread (1963—present) was first encouraged to experiment in her artist mother Pat's studio as a young child and also helped her father build a concrete floor in the cellar of their home to turn it into a workspace.

Whiteread has worked from a number of studios in London, attracted by areas that were rather run down. An early studio was in a former perfume factory on Carpenters Road in Hackney Wick, where she shared a studio complex with the likes of Grayson Perry, and enjoyed poking around in the neighbourhood's disused factories. Later she turned a deconsecrated former synagogue that had been used as a textile warehouse in East London into her high-ceilinged studio and home.

She has since moved north towards Hampstead Heath with a studio in Camden, another large space with a long run of windows along one side and a large skylight, decorated with geraniums grown from cuttings from her father's plants. When moving, she took the opportunity to clear out some of her cluttered studio, including turning the huge amount of paper she had accumulated into papier-mâché that she then used in the construction of her work.

When her children were small, Whiteread aimed to start work in the studio by 9.15am and work until 6pm. She used to run a team working out of two studios, one for sculpture, one for drawings, but now has just the one, although she still likes to keep separate spaces for her drawing and sculpting work. Inside the studio, Whiteread often pins other artists' work to the wall (Piero della Francesca's *The Baptism of Christ*, 1440—50, during the construction of *Ghost*, 1990, a cast of a Victorian living room she likened to 'mummifying the air'). She also enjoys listening to music in the studio, from BBC Radio 4, Max Richter and classical music to Keith Jarrett and David Bowie.

Visitor information

Many studios mentioned in this book either no longer exist or are private property and so cannot be visited by the public. Those mentioned below are open but please do check details and opening times when making arrangements to explore.

Francis Bacon
Bacon's studio is on view at:
The Hugh Lane Gallery, Charlemont House, Parnell Square North, Dublin, Ireland
www.hughlane.ie
Objects and painting equipment from his Paris studio are also on show to the public at:
Francis Bacon MB Art Collection, 21 Boulevard d'Italie, Monaco
www.mbartfoundation.com

Edward Bawden
Brick House is now privately owned. In the latter years of his life, Bawden donated the contents of his studio to The Higgins Bedford museum, which regularly exhibits his work.
The Higgins Bedford, Castle Lane, Bedford MK40 3XD, UK
www.thehigginsbedford.org.uk

Vanessa Bell/Duncan Grant
Charleston, Firle, West Firle, Lewes BN8 6LL, UK
www.charleston.org.uk

Rosa Bonheur
Château de By, 12 rue Rosa Bonheur, Thomery, France
www.chateau-rosa-bonheur.fr

Louise Bourgeois
The home and studio are not open to the public, but the Easton Foundation admits visitors for guided tours by appointment.
The Easton Foundation, 349 West 20th Street, New York, NY 10011, USA
www.theeastonfoundation.org

Constantin Brâncusi
The reconstructed Brâncusi studio is at the Pompidou Centre in Paris.
Place Georges-Pompidou, 75004 Paris, France
www.centrepompidou.fr/en/collection/brancusis-studio

Julia Margaret Cameron
Dimbola, Terrace Lane, Freshwater Bay, Isle of Wight, UK
www.dimbola.co.uk

Paul Cézanne
Atelier de Cezanne, 9 Av. Paul Cézanne,
13090 Aix-en-Provence, France
www.cezanne-en-provence.com/en/the-cezanne-sites/atelier-de-cezanne/

Giorgio de Chirico
Giorgio de Chirico's House Museum, 31 Piazza di Spagna, 00187 Rome, Italy
www.fondazionedechirico.org

Winston Churchill
Chartwell, Mapleton Road, Westerham, Kent TN16 1PS, UK
www.nationaltrust.org.uk/visit/kent/chartwell

Leonardo da Vinci
Château of Le Clos Lucé, 2 rue du Clos Lucé, Amboise, Val de Loire, France
www.vinci-closluce.com

Eugène Delacroix
Musée National Eugène-Delacroix, 6 rue de Furstenberg, 75006 Paris, France
www.musee-delacroix.fr

Albrecht Dürer
Albrecht-Dürer-Haus, Albrecht-Dürer-Straße 39, Nürnberg, Germany
www.museums.nuernberg.de/albrecht-duerer-house

Frida Kahlo
Diego Rivera and Frida Kahlo House Studio Museum,
Av. Altavista & Calle Diego Rivera, Mexico City, Mexico
The Casa Azul/Museo Frida Kahlo, Londres 247,
Col. Del Carmen, Coyoacán, Mexico City, Mexico
www.museofridakahlo.org.mx

Georgia O'Keeffe
The Georgia O'Keeffe Museum runs public tours of the Abiquiú Home and Studio.
21120 US-84, Abiquiu, NM 87510, USA
www.okeeffemuseum.org
Ghost Ranch is an Education & Retreat Center owned and run by the Presbyterian Church, which runs activities, guest accommodation and an artist residency program.
280 Private Drive 1708, Abiquiu, NM, 87510-2001, USA
www.ghostranch.org

Barbara Hepworth
Barbara Hepworth Museum and Sculpture Garden, Barnoon Hill, St Ives, Cornwall, UK
www.tate.org.uk/visit/tate-st-ives/barbara-hepworth-museum-and-sculpture-garden

Hokusai
Tsuyuki Kosho's drawing has inspired two life-sized reproductions.
One is in the Sumida Hokusai Museum, with reasonably lifelike animatronic figures of the artist and his daughter.
2-7-2 Kamezawa, Sumida-ku, Tokyo, Japan
www.hokusai-museum.jp
The other is at the Edo-Tokyo Museum in the form of a diorama.
1-4-1 Yokoami, Sumida-ku, Tokyo, Japan
www.edo-tokyo-museum.or.jp

Tove Jansson
Although you can't visit her studio, there is a memorial plaque to Jansson on the outside wall of the building where she lived and worked at:
Ullanlinnankatu 1, Helsinki, Finland

René Magritte
René Magritte Museum, Esseghemstr., Jette, Brussels, Belgium
www.magrittemuseum.be

Joan Miró
The Mallorca Foundation in Spain is open to the public.
Carrer de Saridakis, 29, Palma, Spain
www.miromallorca.com

Claude Monet
Monet's studios, house and garden at Giverny are open to the public.
84 rue Claude Monet, 27620 Giverny, France
www.fondation-monet.com

Giorgio Morandi
Museo Morandi, Via Don Minzoni 14, 40121 Bologna, Italy
Casa Morandi, Via Fondazza 36, 40125 Bologna, Italy
Both: www.mambo-bologna.org/en/museomorandi
Casa Museo di Giorgio Morandi/House Museum Morandi, Via Ponte Rocchetta 46A Riola, 40030 Grizzana Morandi, Italy
www.rocchetta-mattei.it/en/house-museum-morandi

Sidney Nolan
The Rodd, Presteigne, LD8 2LL, UK
www.sidneynolantrust.org

Jackson Pollock/Lee Krasner
Pollock-Krasner House and Study Center,
830 Springs-Fireplace Road, East Hampton, NY, USA
www.pkhouse.org

Rembrandt
Rembrandthuis, Jodenbreestraat 4, Amsterdam, Netherlands
www.rembrandthuis.nl/en

Auguste Rodin
Although the Pavillon de l'Alma is no longer standing, Rodin's home and park in Meudon is now a museum and his sculpture studio is open to the public.
Musée Rodin Meudon, Villa des Brillants,
19 Av. Auguste Rodin, 92190 Meudon, France
www.meudon.musee-rodin.fr

Joaquín Sorolla
Museo Sorolla, Paseo del General Martínez Campos 37, Madrid, Spain
www.culturaydeporte.gob.es/msorolla/inicio.html

Suzanne Valadon
Musée de Montmartre, 12 rue Cortot, Paris, France
www.museedemontmartre.fr

Index

Main entries are listed in **bold**

A
Abiquiú, New Mexico 139
Aix-en-Provence, France 45
Aldrin, Buzz 182
Alma-Taderna, Sir Lawrence 9
Amsterdam, Netherlands 126, 151, 153
anatomy 114
animals 25–7, 146
Apollinaire, Guillaume 57
Arles, France 172
Arno, Peter 94
Artist's Studio Museum Network 8
astronauts 182
attics 19, 22, 154
Augusta, Princess of Saxe-Gotha 97

B
Bacon, Francis **10–13**, 136, 161
Balzac, Honoré de 142
basements 14, 28, 165
Basquiat, Jean-Michel **14–17**, 178
Bawden, Edward 8, **18–21**
Bazille, Frédéric 61
Beaton, Cecil 10
Beethoven, Ludwig van 161
Bell, Clive 7
Bell, Quentin 22
Bell, Vanessa 8, **22–3**
Bellew, Peter 36
Bennett, Alan 115
Bernard, Émile 46, 171
Beuret, Rose 141
Blondie 17
Bloomsbury Group 22
Boer Wars 53
Bologna, Italy 132
bones 25, 45, 139
Bonheur, Raymond 24
Bonheur, Rosa **24–7**, 141
Bono 30
books 10, 13, 20, 22, 25, 28, 30, 40, 55, 65, 88, 94, 124, 177
Borély, Jules 46
Boswell, James 167
bottega 113
Boucher, Alfred 48
Bourgeois, Louise **28–31**, 43
Bowie, David 185
Brâncusi, Constantin **32–3**, 48, 158
Braque, Georges 142
Britten, Benjamin 136
Bruni, Prudenzia 40
Brussels, Belgium 9, 108
Bürgel, Octavia 178
Byron, Lord 94

C
cabins and huts 22, 48, 91, 129, 130; *see also* sheds
Cairo, Egypt 52
Calder, Alexander **34–7**
Cameron, Hugh 102
Cameron, Julia Margaret **38–9**
Cannes, Frances 142
Canova, Antonio 98
canvases 7, 10, 13, 19, 22, 27, 40, 45, 46, 53, 57, 66, 80, 83, 89, 98, 100, 106, 110, 116, 119, 136, 141, 145, 147, 161, 168
Caravaggio **40–41**
Carlyle, Thomas 102
Carroll, Lewis 175
cars 6, 103, 130, 139
Cartier-Bresson, Henri 10
cats 20, 116, 146, 171
Cennini, Cennino 63
Centre Pompidou, Paris 33
Cézanne, Paul **44–7**, 175
Chagall, Marc **48–9**
chalk 65, 178
Chants de Maldoror, Les (Lautréamont) 124
Chapman, Dinos and Jake 30
charcoal 148, 178
chickens 38
Child, 'Charlie and Lola' 30
children/childcare 75, 161, 185
Chipperfield, David 68
Churchill, Winston **50–53**
cigarettes 17, 27, 83, 125
Clark, Alson 130
Claudel, Camille 30, 141
Cocteau, Jean 142
Coltrane, John 17
comics 165
Cornwall, England 75, 100
Covid-19 162
Coyoacán, Mexico 92
crayons 110, 148
Crimean War 130
critics 22, 46, 51, 57, 58, 63, 64, 75, 100, 113, 175
Crosby, Bing 148
Cubism 142
Czechowska, Lunia 124

D
Da Vinci, Leonardo 30, **54–5**, 114, 115
Daily Telegraph 100
Dalí, Salvador 30, 146, 183
Darwin, Charles 38, 102
Daubigny, Charles François 51, 129, 131
Daumier, Honoré 172
Dawson, Barbara 13
Dawson, David 30
De Chirico, Giorgio **56–7**, 132
De Rossi, Giovanni Gherardo 98
Degas, Edgar 171, 175
Delacroix, Eugène 6, **58–61**, 151, 172
Della Francesco, Piero 185
Dessau, Germany 7
Dickens, Charles 175
Dodgson, Charles, *see* Carroll, Lewis
dogs 141, 146, 166
Dove, Arthur 139
Drouart, Raphaël 53
Du Camp, Maxime 6
Du Pays, Augustin-Joseph 58
Dublin, Ireland 10
Ducasse, Isidore 124
Duchamp, Marcel 35
Dufresne, Isabelle Collin 30
Dufy, Raoul 171
Dürer, Albrecht **62–65**
Düsseldorf, Germany 7

E
easels 6, 27, 40, 45, 46, 53, 57, 91, 92, 94, 98, 110, 119, 125, 126, 130, 131, 140, 153, 168
East Sussex, UK 22
Eastenders 148
Easton Foundation 28
Edo, Japan 84
Eiffel, Gustav 48
Ellet, Elizabeth Fries 25–7
Emerson, Waldo Emerson 78
Emin, Tracey 30, **66–9**
Englewood, USA 154
Essex, England 19
Eyre & Spottiswoode 66, 68

F

factories 28, 66, 103, 135, 185
Factory, The 113, 180, 182–3
fado 148
Farquharson, Joseph 130
Fenton, Roger 6, 130
First World War 51, 52, 53, 100
Fitzgerald, Ella 178
Florence, Italy 54, 71, 113, 115
Franco, Francisco 116
Freedman, Carl 69
Freud, Lucian 13, 30, 146
Friedrich, Caspar David 42
Fry, Roger 22

G

Gagosian, Larry 14
gardens 9, 19–20, 61, 75–6, 111, 123, 141, 148, 154, 162, 165, 168, 175
Garitte, André 111
Garnett, Angelica 22
Garnett, David 22
Garnett, Henrietta 22
Garwood, Tirzah 19
Gasquet, Joachim 46
Gauguin, Paul 172–4
Genoa, Italy 40
Gentileschi, Antonia **70–3**
Gentileschi, Orazio 71
George IV 167
Géricault, Théodore 172
Gershwin, George 178
Ghirlandaio, Domenico 113, 115
Gilbert and George 30
Giles, Carl 165
Giovio, Paolo 114
Glasgow, Scotland 161
Glass, Philip 161
Goethe, Johann Wolfgang von 98
Golding, Ronald 52
Goldsmith, Oliver 167
Goldwater, Robert 28
Gorey, Edward 146
Gormley, Sir Antony 30
Gorovoy, Jerry 30, 31
gouache 31, 110
Grant, Duncan 7, 22
Great Bardfield Artists 19, 20
Greenaway, John 8–9
Greenaway, Kate 6, 8–9
Greenwich Village Society for Historic Preservation 17
Grizzana, Italy 132

H

Hall, James 113
Hamilton, Juan 30
Hamnett, Nina 123, 124
Hancock, Tony 7
Hayles, John 102
Hébuterne, Jeanne 124
Helsinki, Finland 88
Hepworth, Barbara 33, **74–7**
Herefordshire, England 135
Herschel, Sir John 38
Hertfordshire, UK 7
Hipkin, Ashley 30
Hirst, Damien 30, 113, 182
Historic Artists' Homes and Studios 8
Hockney, David 8, 40, **80–83**, 146
Hogarth, William 146, 166
Hokusai, Katsushika **84–7**
Hooker, Sir Joseph Dalton 102
Houbraken Arnold 151
huts, see cabins and huts 22

I

Impressionism 61, 129, 130, 175
ink 63, 165, 178
Isle of Man 53

J

Jagger, Mick 183
Jansson, Tove **88–91**
Jarrett, Keith 185
Jaussard, Jean-Francois 30
Jay-Z 161
Johnson, Samuel 98, 167
Jolie, Angelina 17
Jones, Grace 178
Joseph II, Emperor of Austria 98
Judd, Donald 105
Julius II, Pope 113

K

Kahlo, Frida **92–5**, 106, 146
Kandinsky, Wassily 146
Katsushika Hokusai, see Hokusai
Katsushika, Ōi 86, 87
Kauffman, Angelica **96–9**
Kent, England 50–52, 66
Klee, Paul 7, 146
Klimt, Gustav 146
Klumpke, Anna 141
Knight, Harold 100
Knight, Laura 97, **100–3**
Konikoff, Eva 91
Krasner, Lee **144–7s**
Kusama, Yayoi **104–7**

L

Laidler, Graham ('Pont') 165
Laurvray, Abel 131
Lavery, Sir John 51
Lawrence, T.E. 52
Leenhoff, Suzanne 141
Leighton, Frederick 7, 53
Lenin 94
Leonov, Alexei 182
Leroy, Louis 175
Liaisons dangereuses, Les (Laclos) 124
light 9, 20, 22, 40, 80, 129, 145, 148, 165
Lightfoot, Jessie 10
Linich, William George (Billy Name) 180
London, England 6, 7, 9, 10, 66, 80, 97, 100, 126, 148, 161, 162, 165, 185
Los Angeles, USA 83
Love in the studio 141
Low, David 165
Lubbock, John 121

M

Maar, Dora 142
Madrid, Spain 8, 168
Magritte, Georgette 108
Magritte, René 57, **108–11**, 146
Malanga, Gerard 183
Mallorca, Spain 116
Malta 40
Manet, Édouard 130, 141
Marcopoulos, Ari 178
Marx, Karl 94
Massard, André 36
Matisse, Henri 146
Maupassant, Guy de 88
McCartney, Linda 110
Medici family 72
Melbourne, Australia 135
Mengs, Anton 98
Meyerowitz, Joel 46
Micas, Nathalie 27, 141
Michelangelo 10, 54, 58, **112–15**, 151, 161
Milan, Italy 40
Millais, John Everett 10, 102, 175
Miró, Joan 8, **116–19**, 142
mirrors 10, 19, 22, 92, 165–6
Modigliani Amadeo 48, **122–5**, 142, 171
Mondrian, Piet 35, 119, **126–7**, 151
Monet, Claude 51, 61, **128–31**, 156, 168, 175
Montaigne, Michel de 94
Moomins 88
Moore, Henry 7
Morand, Paul 33
Morandi, Giorgio **132–3**
Morisot, Berthe 171
Morris, William 53
Moser, Mary 97
Moussis, Paul 171
Mozart, Wolfgang Amadeus 58
Munch, Edvard 146
Murray, Edmund 52
Musée d'Orsay 129
music 14, 17, 54, 75, 102, 119, 135, 161, 177, 178, 183, 185

N

Namuth, Hans 147
Nantel, Arthur 53
Naper, Ella 100
Naples, Italy 40
Nash, Paul and John 53
National Portrait Gallery, London 103
National Trust 52, 115
New York, USA 14, 28, 48, 76, 105, 106, 126, 145, 154, 161, 177, 180
newspapers and magazines 10, 30, 178, 182
Nichiren 86
Nicholson, Sir William 51
Nicholson, Winifred 126
Nixon, Richard 105

Nolan, Sidney **134–7**
Nosei, Annina 14
Nuremburg, Germany 63, 64

O
Ofili, Chris 157
O'Gorman, Juan 92
O'Keefe, Georgia 6, 30, 79, 105, **138–41**, 146
oil painting 22, 52, 53, 92, 131, 136, 168
Oldenburg, Claes 105
outdoors, working 6, 45, 52, 80, 129, 135, 168
Oxford, England 161

P
Palermo, Italy 115
palettes 13, 27, 45, 98, 110, 131, 140
Paris, France 7, 10, 25, 27, 33, 35, 48, 57, 58, 108, 116, 123, 125, 126, 129, 141, 142, 158, 171, 175
Parker, Charlie 17
Parshall, Peter 63
Paul III, Pope 114
pencils 166, 182
Pepys, Samuel 102
Perl, Jed 36
Perry, Grayson 185
Perry, Lilla Cabot 131
pets 146
Phare de la Loire 131
Philip II, King of Spain 115
Philip, Beatrice 141
Phillips, Claude 100
Picasso, Pablo 57, 83, **142–3**, 146
Pietilä, Tuulikki 90–1
Pissarro, Camille 175
plants 19–20
plein-air, see outdoors
poetry 36, 57, 75, 94, 119, 120, 124
Pollock, Jackson 7, **144–7**
prisoners of war 53

R
Radiohead 161
Ramsden, E.H. 75
Raphael 58, 65, 151
Ravilious, Eric 19
Ray, Man 33
Rebel, The (1961) 7

Rego, Paula **148–9**
Rembrandt van Rijn **150–3**, 161
Renard, Edward 58
Renoir, Pierre-Auguste 131, 146, 171
Restorick, David 162
Reynolds, Joshua 97
Richter, Max 185
Rilke, Rainer Maria 158
Ringgold, Faith **154–5**
Rivera, Diego 92, 94–5
Rivière, R.P. 46
Robertson's (art supplier) 51
Rockefeller, Nelson 94
Rockwell, Norman 146
Rodin, Auguste 30, 141, **158–9**
Röell, W.F.A 126
Rome, Italy 9, 40, 57, 97–8, 113
Roosevelt, Franklin D. 51
Rosenfeld, Bella 48
Rossetti, Dante Gabriel 53, 146
Rothenstein, Sir John 51
routines, daily 8–9, 36, 61, 75, 80, 95, 106, 119, 140–1, 145, 185
Rower, Alexander 36
Rowlandson, Thomas 166–7
Roxbury, USA 35
Royal Academy of Arts 83, 97, 103
Ruffo, Antonio 72

S
Salaí (Gian Giacomo Caprotti da Oreno) 30
Sargent, John Singer 51, 131
Saville, Jenny 160–1
Schnerb, Jacques 46
Schulz, Charles 146
Schwitters, Kurt 53
Scott-Heron, Gil 178
sculpture 27, 28, 31, 33, 36, 54, 75–6, 89, 92, 105, 116, 158, 177, 180, 182, 185
Searle, Ronald 165
Second World War 19, 20, 53, 88, 103, 132, 135, 165

Sert, Josep Lluís 116, 119
Shaw, George Bernard 158
Shaw, Norman 6
sheds 27, 53, 75, 115, 148
Shonibare, Yinka **162–3**
Sicily, Italy 40
Sickert, Walter 7, 51–2
Siddal, Elizabeth 102
silhouettes 17, 177
Simmonds, Posy **164–7**
Sisley, Alfred 175
Solanas, Valerie 183
Sontag, Susan 180
Sorolla, Joaquín 8, **168–9**
Sotheby's 110
space, art in 182
Spitalfields, London 66
spray paint 135, 136
Steinheil, Louis Charles Auguste 64
Steinlen, Théophile 90
Stieglitz, Alfred 139, 141
studietto 63
Surrealism 108, 124
Sussex, England 8, 22
Swynnerton, Annie 97

T
Tate 51, 76, 125
Tennyson, Alfred, Lord 38
Terry, Ellen 141
Thrale, Hester 98
Tokyo, Japan 105
Toulouse-Lautrec, Henri de 171
Trollope, Anthony 38
Tsuyuki Kōshō 86
Turner, J.M.W. 66, 129

U
Utrillo, Maurice 171
Utter, André 171

V
Valadon, Suzanne 146, **170–71**
Van Dyck, Anthony 115
Van Gogh 84, 120, **172–5**
Van Gogh, Theo 172, 174
Van Hoeydonck, Paul 182
vans 6, 130
Vasari, Giorgio 88, 113, 115
Velázquez, Diego 161
Velvet Underground 183
Victoria & Albert Museum 38

Vietnam War 105
vinyl records 17
Vogue 139, 166

W
Wain, Louis 146
Walker, Kara **176–9**
Walker, Larry 177
warehouses 162, 177, 185
Warhol, Andy 8, 14, 17, 30, 105, 113, 146, **180–3**
watercolours 20, 51, 64, 102, 166–7, 178, 182
Watts, George Frederic 34, 53, 141
Weiss, Jeffrey 63
Whistler, James McNeill 102, 141
Whiteread, Pat 184
Whiteread, Rachel **184–5**
Whitman, Walt 94
Wolfe, Ella and Bertram 95
Wollheim, Bruno 83
Woolf, Virginia 22

Y
Yorkshire, England 80
Young British Artists 66

Z
Zadkine, Ossip 123
Zborowska, Hanka 124
Zola, Émile 88
Zucchi, Antonio 97

Picture credits

Photographs via Getty Images:
10 Raphael Gaillarde; 14 Rose Hartman; 19 Aubrey Hart; 22 George C. Beresford; 25 Hulton Deutsch; 28 Jack Mitchell; 33 Bettmann; 35 Wally McNamee; 38 Julia Margaret Cameron; 40 Universal History Archive; 45 Hulton Archive; 48 ullstein bild Dtl.; 51 Bettmann; 54 The Print Collector/Heritage-Images; 57 Lipnitzki; 58 Sepia Times; 63 Universal History Archive; 66 Neville Elder; 71 Fine Art Images/Heritage-Images;75 Hulton Deutsch; 80 Fairchild Archive; 84 Smithsonian; 89 Hans Paul; 92 Bettmann; 97 Fine Art Images/Heritage-Images; 100 Hulton Deutsch; 105 Alain Nogues; 108 Archive Photos; 113 Culture Club; 116 Keystone-France; 123 Heritage-Images; 126 ullstein bild Dtl.; 129 Heritage Images; 132 brandstaetter images; 135 Ian Showell; 139 Bettmann; 142 ullstein bild Dtl.; 145 Tony Vaccaro; 148 Rita Barros; 151 Universal History Archive; 154 Anthony Barboza; 158 adoc-photos; 161 Nick Harvey; 162 Peter Macdiarmid; 165 Frederic Reglain; 167 Fine Art Images/Heritage-Images; 171 Bettmann; 172 Fine Art Images/Heritage-Images; 177 Jason Kempin; 180 Bill Senft/Newsday LLC; 185 Donald Maclellan

To Philip and Phyllis, Wilma,
Thomas, Edward and Robert

Quarto

First published in 2024
by Frances Lincoln,
an imprint of Quarto.
One Triptych Place, London
SE1 9SH, United Kingdom

(0)20 7700 6700
www.Quarto.com

Text © 2024 Alex Johnson
Illustrations © 2024 James Oses

Every effort has been made to trace the copyright holders of material quoted in this book. If application is made in writing to the publisher, any omissions will be included in future editions.

Front cover illustration: Barbara Hepworth's studio and garden at St Ives, Cornwall, England

Alex Johnson has asserted his moral right to be identified as the Author of this Work in accordance with the Copyright Designs and Patents Act 1988.

All rights reserved. No part of this book may be reproduced or utilized in any form or by any means, electronic or mechanical, including photocopying, recording or by any information storage and retrieval system, without permission in writing from Frances Lincoln.

A catalogue record for this book is available from the British Library.

ISBN 978-0-7112-9378-6
e-Book ISBN 978-0-7112-9379-3

10 9 8 7 6 5 4 3 2 1

Printed in Bosnia and Herzegovina

Alex Johnson is a writer and journalist. He was part of the *Independent*'s online team for 15 years, and is now the online editor for *Fine Books & Collections* magazine as well as writing regular columns for the *Idler* magazine. He also runs Shedworking (www.shedworking.co.uk) and Bookshelf (www.onthebookshelf.co.uk) and enjoys letterpress printing on his Adana 8x5.

James Oses is an illustrator. He draws a variety of subject matter using dip pens, pots of ink, pastels, watercolour and brushes. Selected clients include *The Financial Times*, English Heritage, *The New Yorker*, Berry Bros. & Rudd, Marks & Spencer, *The Guardian*, Borough Market and *The Radio Times*.

Publisher Philip Cooper
Editor Michael Brunström
Editorial Director Nicky Hill
Designer Sally Bond
Senior Designer Isabel Eeles
Art Director Paileen Currie
Senior Production Controller Rohana Yusof